LOUISVILLE
GAMBLING BARONS

BRYAN S. BUSH

THE
History
PRESS

Published by The History Press
Charleston, SC
www.historypress.com

First published 2023

Manufactured in the United States

ISBN 9781467153904

Library of Congress Control Number: 2022949523

Notice: The information in this book is true and complete to the best of our knowledge. It is offered without guarantee on the part of the author or The History Press. The author and The History Press disclaim all liability in connection with the use of this book.

CONTENTS

CONTENTS

Acknowledgements

Special thanks must go to Richard Watts, the descendant of James "Dick" Watts, Union officer, gambler and owner of the Crockford. With his groundbreaking research on gambling in Louisville, the book would not have been possible. Special thanks must be given to the Louisville Public Library, Cave Hill Cemetery, in Louisville, Kentucky, Spring Hill Cemetery, in Harrodsburg, Kentucky.

Introduction

During the 1700s and early 1800s, stagecoaches and the first steamboats brought visitors to Louisville. The boardinghouses and taverns along the wharf became areas where visitors could play poker, billiards and faro. A game of cards or dice could easily be played with little setup.[1] In 1821, the steamboat era began and flourished for fifty years. In 1830, rivers and steamboats began to take off as the new superhighways. That year, there were about 90,000 men employed in the river trade, and just ten years later, the laborers, engineers, pilots, repairers and crews employed in the river trade exploded to 180,000. In 1830, there was $3 million invested in steamboats. In 1834, there were 230 steamboats on the Mississippi, and by 1842, there were 450 vessels, with a value of $25 million. The golden age of steamboats ran from 1848 until the end of the Civil War. Six thousand steamboats of more than one million tons were built and run on the Mississippi and its tributaries from 1820 to 1880. The steamboats brought professional steamboat gamblers to Louisville. During the 1850s, the Louisville–New Orleans river route held top rank on the entire western river system in freight and passenger traffic. The population in Louisville grew to the point where the city was the tenth largest in the United States. By 1855, the railroad had arrived, bringing even more people to the vibrant river city.

During the Civil War, Louisville had hundreds of thousands of Union soldiers who arrived by steamboat, and the Louisville and Nashville took soldiers, supplies, and ammunition to Nashville. Once they arrived in

Nashville, the soldiers spread out across the South. With so many soldiers in Louisville during the war, gambling took off as an industry. The soldiers played faro, keno, roulette and other games of chance, such as chuck-a-luck. Entire city blocks were devoted to gambling. Horse racing and lotteries were also played in the city.

After the Civil War, Louisville entered the golden age of gambling, which ran from 1870 to 1885. The railroad lines in Louisville connected with the East, West, South and North. In 1885, the L&N had control of 2,027 miles of track and transported 569,149 people. Steamboats continued to bring people into the city. Louisville's major industries were bourbon and tobacco, but Louisville was also the leading maker of plows in the world. Additionally, the city manufactured cement, pipes and wagons, just to name a few. With so many millionaires in the city, they were looking for high entertainment. Riverboat gamblers flowed into the city. Gambling houses became grand palaces, with such names as the Crockford, the Crawford and the Turf Exchange. Horse racing made a resurgence after the Civil War, and Churchill Downs had its first Derby in 1875. In 1894, Emil Bourlier bought the Jockey Club, saved Churchill Downs from bankruptcy and made massive renovations.

During the golden age of gambling, Louisville became known as the "Monaco of the United States," and "The City of Gamblers." Infamous and famous gamblers such as James Richard Watts, Steve Holcombe, Anderson Waddell and Colonel "Black" Jack Chinn became famous for their gambling. Hundreds of thousands of dollars were lost and won on the faro tables. Gamblers armed themselves with a derringer or knife for protection in case the card game turned for the worse. Card duels between famous gamblers sometimes went into multiple days, and thousands of dollars were on the table. Even famous actors such as Nat Goodwin or minstrel show owner Jack Haverly gambled hundreds of thousands of dollars in a game. Betting on horse racing went from bookmaking to pari-mutuel machines, and not only did the turf betting houses take bets from Churchill Downs, but telegraph lines and later telephones brought in bets from other racetracks such as Saratoga in New York or Latonia in Covington, Kentucky, as well. Gambling house owners such as Chief of the Fire Department Edward Hughes, James "Dick" Watts, Anderson Waddell, Eli Marks, Henry Wehmhoff and James Cornell made millions.

The beginning of the end started in 1876, when citizens started to complain about gambling houses bringing out the worst in the city, such as crimes of the petty pickpocket to murder. By 1885, an organization

known as the Law and Order Club had forced the city to pass laws against disreputable houses. Saloons and gambling houses were constantly raided by the police. They arrested the owners and managers of the houses and took all their gaming paraphernalia. Heavy fines were levied against the gambling houses until the owners closed their houses. Prohibition put a final end to the gambling houses. Most of the saloons had gambling rooms upstairs on the second or third floors, so when the liquor stopped flowing, so did the money in gambling houses. Lotteries came to an end, and eventually only Churchill Downs was allowed to make bets.

Since the late 1990s and the 2000, the state of Kentucky and Louisville have had a resurgence of gambling. The Kentucky Lottery, keno and trackside betting have made a comeback to the city. The newest casino gaming–style betting to arrive in Louisville is called "historical horse racing," with such places as Derby City Gaming Downtown and the Red Mile. The HHR machines look like slot machines. With Indiana having casinos just across the river at Caesar's Palace and Belterra, Kentucky has begun to reevaluate casinos in the state. Future can only tell if the gambling palaces of days gone by will return to the river city.

1

THE GAMBLING HISTORY
OF LOUISVILLE

GAMBLING IN LOUISVILLE: 1700s–1850s

Early in the nineteenth century, lotteries, which were drawn at local taverns, gained popularity in the city. Schools, churches, relief funds, medical organizations and the military used the lottery as a way to help their organizations raise money without paying taxes. During the years of recession and depression in 1798, 1816, 1818 and 1822, organizations used lotteries to keep from going bankrupt. With the vast amounts of money being raised came corruption, and the citizens of Louisville began to protest lotteries. The same humanitarian organizations that led crusades against slavery and temperance also took up the cause against lotteries, stating that the lottery was just another form of gambling. In 1852, the Kentucky General Assembly outlawed lotteries, but the law lasted only three years. By 1862, Kentucky was only one of three states in the Union with a statewide lottery, which was against the nationwide anti-lottery crusade.[2]

Horse racing began as early as 1815 at the Louisville Turf, which was located on Sixteenth Street and next to the Hope Distillery. During the mid-1820s, the Beargrass Track was established near the present-day Hurstbourne Parkway area. By 1832, the Oakland Racecourse, which was located on Seventh Street, south of Magnolia Avenue, had replaced the Louisville Turf. Betting on horse races was not a public affair and was usually conducted by the upper echelons of the southern elite. Bets were made by the horse owners, their friends and servants or occasionally slaves.

In 1857, reformed gambler Jonathan Harrington Green wrote a book titled *Gambling Exposed: A Full Exposition of All Various Arts, Mysteries, and Miseries*. He offered this description of the spring races in Louisville in 1841:

> *Every caste were there to partake of the benefits of the sports of the week. Here might the eye have taken in, at one glance, all the different grades of his profession. At the close of the week they began to operate in such a manner as is characteristic of this class of men....They are formed into classes as follows: the first class consists of faro-dealers, the second class is composed by of an inferior grade of faro-dealers, the third class is made up of those who play roulette, chucker luck, or other species of small, plain villainy. The characters composed of number 3 are men who are generally formed the fighters, or the low-bred bullies; the class number 4 are men that play thimbles or trunk-lieu, or, in other and plain language, they are pickpockets.* [3]

By the 1850s, horse racing was in decline, and the Oakland Racecourse closed during a recession.[4]

In the mid-nineteenth century, Louisville became a vibrant and wealthy city, the tenth largest in the United States. Louisville's population rose from ten thousand in 1830 to forty-three thousand in 1850. The city became an important tobacco market and pork packing center. By 1850, Louisville's wholesale trade totaled $20 million in sales. The Louisville–New Orleans river route held top rank in the west in freight and passenger traffic. Not only did Louisville profit from the river, but in August 1855, Louisville citizens greeted the arrival of the locomotive *Hart County* on Ninth and Broadway and the first passengers arrived by train on the Louisville and Frankfort Railroad as well.[5]

With the railroad, Louisville could manufacture furniture and export the pieces to southern cities. Louisville was well on its way to becoming an industrial city. The Louisville Rolling Mill built girders and rails and cotton machinery that was sold to southern customers. Louisville also built steamboats. Louisville emerged as an ironworking industry with a plant on Tenth and Main called Ainslie, Cochran and Company.[6]

Louisville also manufactured hemp rope and cotton bagging. Cotton bagging was made of hemp, and hemp was also used to bale cotton. Hemp was Kentucky's leading agricultural product from 1840 to 1860, and Louisville was the nation's leading hemp market. Louisville also made jean cloth for the slave market. The city's markets broke down into wholesale groceries,

dry goods houses and drug wholesalers. The city had eight pork houses, slaughtering and packing 300,000 hogs a year. Tobacco outranked meat as Louisville's chief product, and the three main warehouses were located at Boone, Pickett and Ninth Street. Dennis Long and Company was the largest pipe manufacturing company in the West. The cement manufactured in the city was the best in the country. The Rolling Mill Company was the largest in the city. B.F. Avery & Company; Munn's; and Brinly, Dodge and Company made many of the plows in the South and Southwest. The Peter Bradas Company made cough drops from a formula given it by Jenny Lind. Cornwall and Brother made soap and candles. The city also introduced glycerin into commerce. Needham's Marble Shop carried Italian, Egyptian, Irish and Sienna marble. McDermott and McGrain made a cooking stove called the "Durable Kentuckian." John Bull made Fluid of Sarsaparilla and sold his drink to New Mexico and Cuba. Hays, Craig and Company made the city's finest furs and peltries. The largest printing company in Louisville was John P. Morton and Company. The paper used in the printing and publishing company, located at Tenth and Rowan, came from Alfred Victor and Antoine Bidermann du Pont.

The steamboat route from Louisville to New Orleans held the top position for western river freight and passenger traffic, and the Louisville-Cincinnati route was the most crowded and most prestigious. Between August 25, 1848, and August 31, 1849, sixty-six different steamboats made 213 trips from Louisville to New Orleans. Between July 1854 and October 1855, Louisville shipbuilders constructed forty-one steamers. The steamboat industry employed 350 men building twenty-two boats a year and repairing another fifty. The Louisville Rolling Mill not only made boilers and machinery for the construction of steamboats but also, more importantly, began to make iron rails, bridge girders and steam boilers for trains. A new industry began to take shape in the city. By the mid-1850s, Ainslie, Cochran and Company, located on Tenth and Main, had built a plant in order to meet the ever-demanding supply for steam engines, cotton gin machinery, wheels and castings for railroad cars. The company claimed its plant was the largest in the West.[7]

By the late 1850s, railroads had begun to overtake steamboats. Louisville had connections with Cincinnati, Pittsburgh, St. Louis, Memphis, Vicksburg and New Orleans. A river ferry to Jeffersonville or New Albany connected with the rail lines extending to St. Louis and Missouri, east of Pittsburgh and north to the Great Lakes. Louisville had lines extending to Memphis, Nashville and Knoxville. The line to Lexington eventually extended to Virginia. The

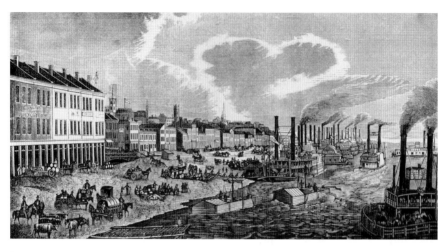

Louisville Wharf, 1850. Steamboats brought not only products in and out of the city but also professional riverboat gamblers. *From* Harper's Weekly.

Louisville railroad also linked with the Baltimore and Ohio Railroad. Other rail lines that ran to Louisville was the Louisville, New Albany and Chicago Railroad, which ran two trains daily to St. Louis, Chicago and Cincinnati. When Louisville connected with Nashville, Louisville became the "gateway to the South."[8]

THE CIVIL WAR:
GAMBLING "BURNED INTO A FEVER" IN THE CITY

On April 12, 1861, the Civil War began when Confederate general P.G.T. Beauregard fired on Fort Sumter in the Charleston, South Carolina harbor. Fort Sumter, commanded by Louisville resident Union general Robert Anderson, surrendered to the Confederates. Three days later, Lincoln called for seventy-five thousand volunteers, and the secretary of war informed the governor of Kentucky, Beriah Magoffin, that four regiments of militia should be raised for the Union. Magoffin wrote back to Secretary of War Simon Cameron, "Kentucky will furnish no troops for the wicked purpose of subduing her sister Southern states."[9]

On May 20, 1861, Kentucky declared its neutrality. An important state geographically, Kentucky had the Ohio River as a natural barrier. Kentucky's natural resources, manpower and the Louisville and Nashville Railroad made both the North and South respect Kentucky's neutrality. Even though

Kentucky's neutrality aided the Confederacy, Lincoln did little to stop the shipments of military supplies heading south by rail and river. The L&N's depot on Ninth and Broadway in Louisville and the steamboats at Louisville wharfs sent uniforms, lead, bacon, coffee and war materiel to Tennessee, Alabama, Georgia and other southern states. Crop failures in the southern states in 1860 led the Louisville & Nashville Railroad to ship supplies to these Southern markets at an ever-increasing rate. Union troops blocked the Mobile and Ohio Railroad from sending provisions south, so the Louisville and Nashville Railroad became the only outlet for supplies in the South. Prices began to soar, and Northern businessmen made fortunes overnight.[10]

On September 4, 1861, Confederate general Leonidas Polk broke Kentucky's neutrality by invading Columbus. As a result of the Confederate invasion, Union general Ulysses S. Grant entered Paducah, Kentucky. Confederate president Jefferson Davis allowed Confederate troops to stay in Kentucky. Confederate general Albert Sidney Johnston, commander of all Confederate forces in the West, sent Confederate general Simon Bolivar Buckner of Kentucky to invade Bowling Green, Kentucky. With twenty thousand troops, General Albert Sidney Johnston established a defensive line stretching from Columbus in western Kentucky, under the command of General Leonidas Polk, to the Cumberland Gap, controlled by Confederate general Felix Zollicoffer.[11]

On September 6, 1861, Union general Robert Anderson moved his headquarters to Louisville. On September 23, 1861, the 49th Ohio, under the command of Colonel Gibson, arrived in Louisville to embark on the Louisville and Nashville Railroad. They paraded through the streets, and the Union men and women came out to greet the soldiers. The regiment stopped to pay their respects to General Anderson at the Louisville Hotel. General Anderson appeared on the balcony and thanked the Ohio regiment for complimenting him and welcomed them to Louisville. He told them that they had come at a time when Kentucky needed their services and that every Kentuckian would appreciate their motives.[12]

By early October 1861, Louisville had become a staging ground for Union troops heading south. Soldiers flowed into Louisville from Ohio, Indiana, Pennsylvania and Wisconsin. White tents and training grounds sprang up at the Oakland racetrack on Eighteenth and Broadway, one along the Bardstown Pike; several camps arose around the L&N tracks just south of the city; and camps appeared in Portland. Camps were also established at Eighteenth and Broadway, along the Frankfort and Bardstown turnpikes.[13]

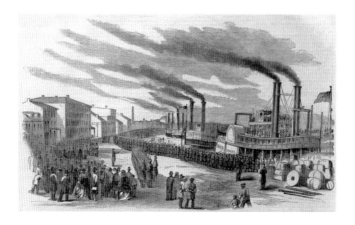

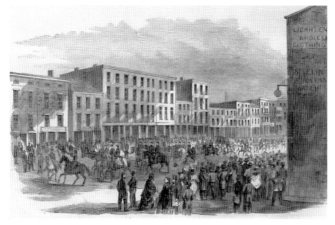

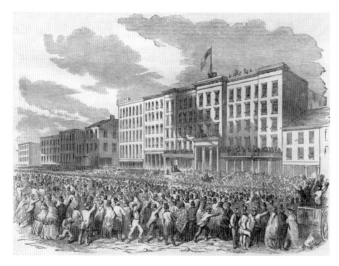

Top: Union troops from Ohio arriving on the Louisville wharf, January 11, 1862. *From* Harper's Weekly.

Middle: Union general Don Carlos Buell's bodyguard parading east on Main Street at Fifth Street in January 1862. *From* Harper's Weekly.

Bottom: The arrival of the 49th Ohio Infantry as they march past the Louisville Hotel, October 19, 1861. *From* Harper's Weekly.

By October 20, Union general William T. Sherman had seventeen regiments from Indiana, thirteen from Ohio, three from Pennsylvania and several other regiments in the state ready to move at a moment's notice toward the Green River or the Cumberland Gap. Two days later, on October 22, 3,800 Pennsylvania troops disembarked from six steamers and paraded through the city. Two brass bands and drum corps played martial music as they went by the hotel, and the troops that followed passed in review by Sherman and the Galt House. Eight six-pound cannons with caissons rolled down the streets followed by 120 horses. The troops camped near the old Oakland racetrack located on Seventh and Hill Streets.[14]

Union regiments continued to flow into the city. On November 9, Colonel Curran Pope and the 15th Kentucky Union Infantry marched through the streets of Louisville. Several days later, on November 11, the 1st and 2nd Wisconsin arrived in town. On November 24, five steamers brought five thousand soldiers from Ohio. One of the regiments that arrived on the steamers was the 21st Ohio Infantry. By January 1, 1862, Louisville had eighty thousand Union troops throughout the city. By March 1, 1862, twenty-eight regiments camped around the city. Union camps sprang up at the Institution for the Blind, around Preston's Woods, along the Bardstown Road between Cave Hill Cemetery and Grinstead Drive, at the Fairgrounds and in Portland in areas south of the city. The House of Refuge, now on the University of Louisville campus, became the Park Barracks and contained one thousand men.[15]

After the Battle of Mill Springs, Kentucky, in on January 19, 1862, and the falls of Forts Henry and Donelson in February 1862, Confederate forces left Kentucky, but during the summer of 1862, Confederates General Braxton Bragg and Major General Edmund Kirby Smith met in Chattanooga, Tennessee, on July 31, 1862, to plan their invasion of Kentucky. Both generals were hoping to bring Kentucky into the fold of the Confederacy, but neither general decided to take Lexington, Louisville, some location or locations on the Ohio River or the railroads. One of the objectives of the Confederate campaign in Kentucky was to possibly seize the Louisville and Portland Canal, severing Union supply routes on the Ohio River. General P.G.T. Beauregard suggested destroying the Louisville canal so completely that "future travelers would hardly know where it was." Edmund Kirby Smith was the first to enter the state on August 18, 1862. By August 29, the advance regiments had begun their movement north into the Bluegrass.[16]

Union general Don Carlos Buell's Union army withdrew from Alabama and headed back to Kentucky. On August 28, Bragg's army crossed the

Tennessee River at Chattanooga and began his march north to Kentucky. On September 3, Confederate general Edmund Kirby Smith took Frankfort. On September 4, 1862, Smith entered Lexington, Kentucky. On September 24, advance units under General Don Carlos Buell's army arrived in the city. On September 26, 1862, Buell's entire army arrived in Louisville. On October 2, 1862, the Union army marched out of Louisville with sixty thousand men. On October 8, 1862, the largest battle in the state of Kentucky would be fought at Perryville, resulting in over eight thousand causalities. Confederate general Braxton Bragg, commander of the Army of the Mississippi, and Confederate general Edmund Kirby Smith, commander of the Department of East Tennessee, left the state, never to return.

After the Battle of Perryville, Kentucky remained in Union hands for the rest of the war. Soldiers continued to occupy the city. When the war ended in April 1865, the Union army began to disband. During June 1865, 96,796 troops and 8,896 animals left Washington, D.C., and headed for the Ohio valley, where 70,000 soldiers took steamboats to Louisville and the remainder embarked for St. Louis and Cincinnati. The troops boarded ninety-two steamboats at Parkersburg and descended the river in convoys of eight boats, to the sounds of cheering crowds and booming cannon salutes at every port city. The XVII, the XV and the XIV Corps arrived in Louisville. By June 4, the Union Army of Tennessee had established headquarters in Louisville. By June 20, 1865, the city was ringed with thousands of soldiers' tents; the troops were restless, tired of war and wanted to go home. The U.S. Paymaster

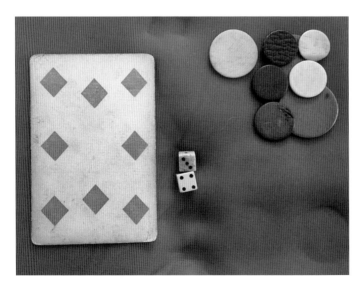

Gambling set from the Civil War with an original Civil War playing card, bone dice and bone gambling "checks" or chips. *Author's personal collection.*

Advertisement of Union playing cards, 1862. *Library of Congress.*

Department paid many of the soldiers their last monthly payment for being in the army. Some of the soldiers received several months' back pay. With Union soldiers' pockets bulging with federal money, the city experienced an economic boom. Soldiers visited the Louisville Theater, the officers stayed in the Louisville Hotel or the National Hotel and they both visited the Louisville casinos.[17]

With hundreds of thousands of soldiers occupying Louisville during the Civil War, young men had money in their pockets to spend in the city, which included restaurants, hotels and, of course, gambling houses. Gambling "burned into a fever that seemed all consuming during the Civil War. There were just enough gambling houses, with enough patrons and free money to keep them open day and night."[18] The poor as well as the rich played at the tables. Many professional riverboat gamblers reaped a fortune from the army officers and contractors who stayed in the city. The *Louisville Journal* reported one incident of an army contractor losing more than a $250,000 at one of the gambling "sessions." These "gilded temples" made no effort at covering up and openly occupied whole blocks in the central part of the city. All of the north side of Jefferson Street from Fourth to Fifth, the east side of Fifth from Jefferson to Market and practically all of the south side of Market from Fifth to Fourth Streets was devoted almost exclusively to keno, roulette, faro and chuck-a-luck. The doors in the gambling casinos and saloons had no locks because they never closed. During the Civil War, gambling houses were packed with Union and Confederate officers and men who profited from the war contracts.[19]

For those who are not familiar with chuck-a-luck, which was also known as the "sweat cloth," the game of chance favors the dealer rather than the players. No skill is necessary. The dealer hosting the game has a cloth marked into six spaces numbered 1 through 6. The "playing board" could be traced into the dirt if one did not have a cloth, or the soldier could make a homemade board out of a blanket. Players select their number by placing their money on the appropriate square. The dealer then rolls three dice. If the player's number comes up on one of the dice, the player wins and gets their money back. If that number comes up on two dice, the player

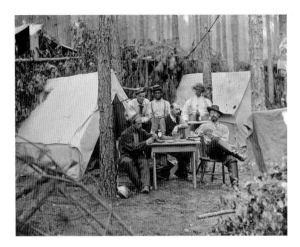

Left: Officers of the 114th Pennsylvania Infantry playing cards in front of their tents. *Library of Congress.*

Opposite, top: Soldiers of the 134th Illinois Infantry playing cards at Columbus, Kentucky. *Library of Congress.*

Opposite, bottom: Three unidentified soldiers playing cards, smoking and drinking in front of American flag. *Library of Congress.*

doubles their money; if the number comes up three times, the winnings are tripled. The odds, however, are in the dealer's favor, because the dealer gets all the money left that does not come up on the dice. There are more complicated versions of the game, but common soldiers in the city played the basic version of chuck-a-luck. Modern versions involve a birdcage or a wheel where the three dice come out of the slot of the cage and are used in the more high-class casinos and saloons.[20]

According to the 1864 book *The American Hoyle, Or, Gentleman's Games Hand-book of Games*, faro or faro banks was also called "bucking the tiger" or "twisting the tiger's tail." It is a card game played with an entire deck of playing cards. How is the game played? The dealer sits at a table prepared for the purpose with an assistant or "looker-out" at his right hand. On the center of the table is a suit of cards arranged in the following order, on which the players place their money or stakes, called "the lay-out." The lay-out is as follows: the king, queen and jack are called "the Big Figure"; the ace, deuce and trois "the Little Figure"; and the six, seven and eight "the Pot." The circles represent the money or checks (chips) of the players, who have made their bets. The check (chips) between the king and queen are bet on both those cards; those on the corner of the ten take in the ten and eight, barring the nine; the check (chip) in the pot is bet on the six, seven and eight; that between the ten and four takes in those two cards, while that behind the four includes the three, four and five; the chip "flat-foot" on the ace, is bet on that card only; the money in the "Jack square" includes the jack, queen, deuce and trois; the chip on the corner of the five, according to the rule in the northern states, is bet on the five and eight, but in the South, it would bar the eight and include the five, nine

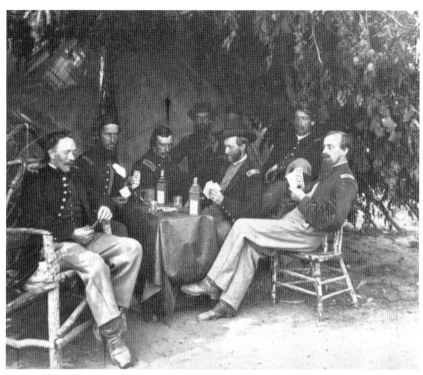

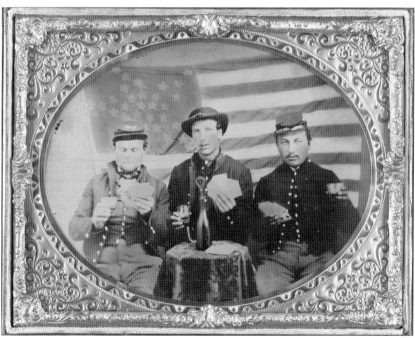

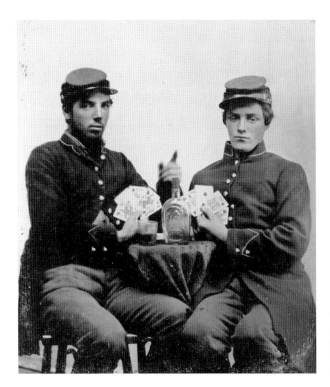

Two unidentified soldiers in Union uniforms drinking whiskey and playing cards. *Library of Congress.*

and six. The stakes usually consist of counters or checks (chips) made of ivory, representing different sums; they are purchased from the banker and redeemed by him at the option of the holder. The banker usually limits the sums to bet according to the amount of his capital. The game may be played by any number of persons, and each player may select any card or number of cards on the lay-out and may change his bet from one card to another whenever he pleases.

How did you deal the cards? After the players set their stakes on the lay-out and all other preliminaries are settled, the dealer shuffles the cards, cuts them and places them faceup in a small metal box, usually silver, that is a little larger than the pack to be dealt. This box is open at the top so that the top card is always in view. It also has a small opening at the side, large enough to permit a single card to pass through it conveniently. As the cards are pushed out or dealt from the top through this opening, the remainder of the deck is forced upward by springs placed in the bottom of the box, and thus the cards are kept in their proper place until the pack is exhausted. We will suppose, by way of illustration, that the ace is the top card, as it appears in the box; this card is shoved through the opening,

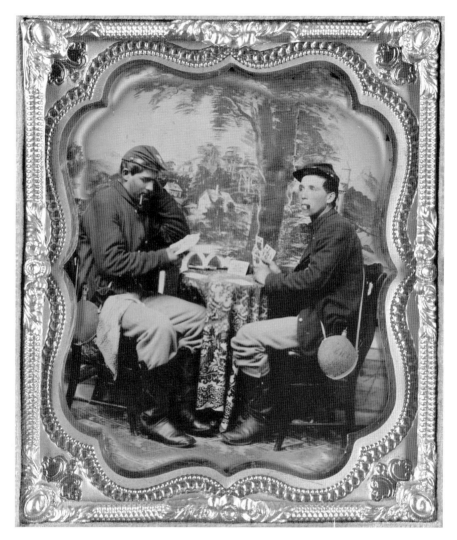

Two unidentified soldiers in Union uniforms with canteens and playing cards, smoking in front of painted backdrop showing landscape with houses and trees. *Library of Congress.*

when a ten appears—this is the banker's card, and he wins all the money that has been placed on it; the ten, like the ace, is removed, disclosing a king, which is the player's card, the bank losing all the stakes found on it. The drawing of these two cards is called "a turn," after which the dealer takes and pays all the money won and lost and then proceeds as before, drawing out two more cards—the first for the bank and the second for the player, and thus he continues until the whole pack is dealt out.[21]

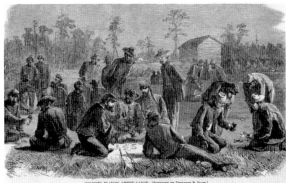

Top: General Patrick's Punishment for Gambling, October 1863. *Library of Congress.*

Bottom: Civil War soldiers playing Chuck-A-Luck. *From* Harper's Weekly.

Whenever two cards of the same denomination, as, for example, two sevens or two fours, appear in the same turn, the dealer takes half the money found on the card—this is called a "split" and is said to be the bank's greatest percentage. To avoid this, old faro players wait until there is one seven or four or card of any other denomination left in the box and then place their heavy bets on that, thus avoiding the possibility of a split. If a player wishes to play on the banker's card or bet that any certain card will lose, he indicates it by placing a copper on the top of his stake, and if this card wins for the bank, the player also wins. When there is one turn left in the box, the player has the privilege of "calling the last turn"—that is, guessing the order in which the cards will appear, and if he calls it correctly, he receives four times the amount of his stake.

How did you keep the game? As it is important for both dealer and player that the cards remaining in the box should be known, the game is accurately kept, so as to exhibit at a glance every phase of the deal. For this purpose, printed cards are given to the players, on which they keep the game in the following manner: No. 1. The image on page 27, marked as the cards are

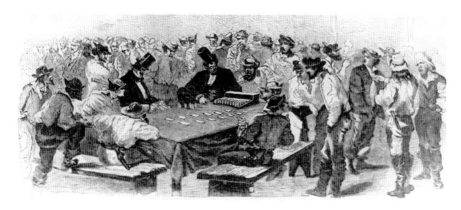

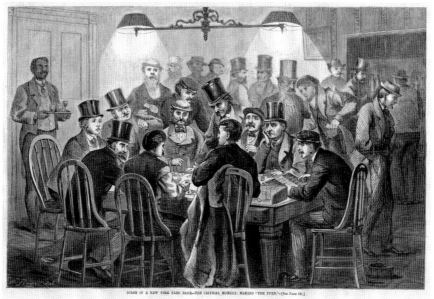

Top: Faro. *From* Harper's Weekly, *October 3, 1857.*

Bottom: A faro game illustrated in *Harper's Weekly* in 1867, "Scene in a New York Faro Bank—The Critical Moment; Making the Turn." The same scene could have taken place in any of the Faro banks in Louisville. *Etching from* Harper's Weekly, *1867.*

dealt, exhibits what each card has done; the 0 means that the card lost—the 1, that it won; thus, the ace lost, won, lost and won; the four lost twice and won twice; the seven won four times, the queen lost four times, and the jack split, lost and won the + indicating a split; the six was the top, or "soda" card, as shown *; the nine won, lost and won, the fourth nine remaining in the box, being the last, or "hock" card, which is indicated by the f. No. 2.—This image

illustrates a deal partly made. One ace has been dealt, and three remain in the box; two deuces have lost, and two remain in the box; four was the top card, and all the sevens remain in the box, and so on. At this stage of the game, cautious players would avoid betting on the seven, ten or jack, preferring the three, six or nine, because on these latter cards they cannot be split, as there is but one of each in the box, while the seven, ten and jack are all in the box and are therefore liable to split or appear before the others.

What is "keeping the game by a cue-box"? Another mode of keeping the game, common in the northern states, was by a "cue-box," by which the different stages of the game are correctly noted by one of the players or by a regular "cuekeeper," who is usually attached to the bank. The cue-box is a miniature "lay-out," with four buttons attached to each card.[22]

At the beginning of each deal, the buttons, which are placed on wire, extending from card, as represented, are all shoved close up to the card, as illustrated by the ten and four; as soon as a turn is made, the buttons are pushed to the opposite end of the wire, as shown by the five, six, seven, jack and so on, so that by a glance of the eye, the player can see how many of each card remain in the dealer's box. As represented below, three kings, two queens, one jack, three nines, three sevens, three fives, one deuce and two aces remain to be dealt, while none of the tens, eights, fours or threes have yet appeared; all the sixes are out, and the six, therefore, is said to be "dead," because no more remain to be dealt.[23]

The technical terms used in faro were as follows:

BANKER OR BACKER. The person who furnishes the money for the game.

TO BAR A BET. A player having a bet on a card who wishes to bar it for a turn must say to the dealer, "I bar this bet for the turn," pointing to it, in which case, it can neither lose nor win.

BETTING EVEN STAKES. When a player constantly bets the same amount.

CAT OR CAT HARPEN. When the last turn consists of two cards of the same denomination and one other card, such as two tens and a king, it is called a cat.

CHECKS. Ivory tokens representing money with which the game is played; they vary in color, size and value.

COPPERING A BET. If a player wishes to bet that a card will lose (that is, win for the bank), he indicates his wish by placing a cent, or whatever may be provided for that purpose, on the top of his stake. It is called "coppering" because coppers were first used to distinguish such bets.

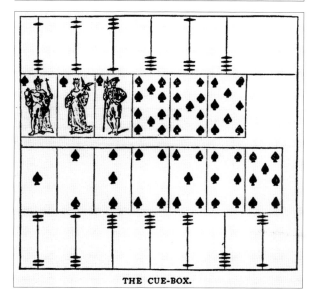

No. 1.				No. 2.		
A—0	1	0	1	A—1		
2—0	0	0	0	2—0	0	
3—1	0	0	1	3—0	0	0
4—0	0	1	1	• 4—		
5—0	0	1	0	5—0	1	
• 6—1	0	1		6—0	1	1
7—1	1	1	1	7—		
8—1	1	0	0	8—1	1	
9—1	0	1	‡	9—0	1	1
10—1	1	1	0	10—		
J—+		0	1	J—		
Q—0	0	0	0	Q—1		
K—1	1	0	0	K—0		

THE CUE-BOX.

Top: Table of Odds on winning at the faro table from the 1864 "*Trumps,*" *The American Hoyle, Or, Gentleman's Hand-Book of Games: Containing All the Games Played in the United States, with Descriptions, and Technicalities, Adapted to the American Methods of Playing. Dick & Fitzgerald Publishers, New York.*

Bottom: Illustration of a cue box from the 1864 book "*Trumps,*" *The American Hoyle, Or, Gentleman's Hand-Book of Games: Containing All the Games Played in the United States, with Descriptions, and Technicalities, Adapted to the American Methods of Playing. Dick & Fitzgerald Publishers, New York.*

CUE OR CASE-KEEPER. The person who marks game on the cue-box.

DEAL. The dealer is said to have made a deal when he has dealt out the whole deck.

DEALER. He who deals the cards and takes and pays the bets.

HOCK OR HOCKELTY CARD. The last card remaining in the box after the deal has been made. When one turn remains to be made, there are three cards in the box. They may be, for example, the five, six and seven; we will suppose the last turn to be five, six, leaving the seven in the box, which would be called the hock card, because, as the game was originally played, the dealer took "hock"—that is, all the money that happened to be placed on that card; the bank, therefore, had a certainty of winning that money without the possibility of losing it—hence the term *hock*, which means "certainty."

LAST CALL. When three cards remain in the box, any player has the privilege of calling the order in which they will be dealt—this is termed the *last call*. The checks are placed so as to express the call, and if correctly made, the bank pays four for one, and if a "cat," two for one.

LOOKER-OUT. The dealer's assistant.

PAROLI OR PARLEE. Suppose a player bets five dollars on the ace, it wins and the dealer pays it; if the player then allows the ten dollars to remain on the ace, he is said to play his paroli, which means "the original stake and all its winnings."

PLAYING A BET OPEN. To bet a card will win, not lose.

PRESSING A BET. To add to the original stake.

REPEATING AND REVERSING. A card is said to repeat when it plays as it did on the previous deal and to reverse when it plays directly opposite—that is, if it won four times, it is said to reverse if it loses four times.[24]

STRINGING A BET. Taking in one or more cards remote from the one on which the bet is placed.

TURN. The two cards drawn from the dealer's box—one for the bank and the other for the player—which thus determine the events of the game constitute a turn.

During the Civil War, soldiers in Louisville also played keno. According to *The American Hoyle, Or, Gentleman's Games Hand-Book of Games* (1864), keno was played with

> one hundred ivory knobs or balls, about the size of a boy's marble, numbered from 1 to 100, and a board with cavities cut therein, to place

the balls as drawn. Upon each card are three lines of figures, each line having five numbers, such as, 24, 16, 9, 40, 3. These lines are formed by the different combinations of all the numbers from one to hundred. At the beginning of the game each player buys a card, at a price mutually agreed upon, this money constituting the pool to be played for. The balls are then carefully examined, and put into an urn. The balls being thoroughly mixed by several revolutions of the urn, the valve at the bottom is opened, and a single ball drops out, and its number announced by the conductor. The player, who happens to have the number upon his card, immediately places a button upon it. Again, the urn is revolved and a second number proclaimed, which is noted in the same manner, by a button, as the first; and thus the numbers are continued to be drawn, until one of the players cries, "Keno!" which means that the five numbers upon one of his lines have been drawn. The card is then submitted for inspection, and, if correct, the fortunate player receives the pool, minus the percentage taken by the keeper of the game. The balls are then returned to the urn, and the play goes on as before, with the same cards, or others, at the option of the player of the game.[25]

In Louisville, the soldiers also played French roulette or American roulette. The table used for this game is an

oblong square covered with green cloth. In the center, there is a round cavity, around the sides of which, equidistant one from the other, are ranged several bands of copper, which, commencing at the top, descend just to the extremity of the machine. In the center of this cavity, which is movable, is a circular bottom containing thirty-eight holes, to which the copper bands are attached and on which are painted alternately, in black and red, thirty-six numbers, from one to thirty-six, a zero (0), and a double zero (00). In the middle is a copper moulinet, surmounted by a cross, which serves to impress the bottom with a rotary motion. There are a banker and several assistants— the number of players is unlimited.

One of the assistants sets the machine in motion, throwing at the same instant an ivory ball into the concavity in an opposite direction to the movement he has given to the movable bottom. The ball makes several revolutions with great velocity, until, its momentum being exhausted, it falls into one of the 38 holes formed by the copper bands. It is the hole into which the ball falls that determines the gain or the loss of the numerous chances which this game presents. To the right and left of the moulinet are figured

on the green cloth, for the accommodation of the players, the 36 numbers and the zeros, simple and double. The other chances are also designated on the green cloth divergent from its center; on one side l'impair, la manque, and rouge; and on the opposite, pair, passe, and noir. The impair wins when the ball enters a hole numbered impair; the manque, when it enters a hole numbered 18, and all those under that number; the rouge wins when the ball enters a hole of which the number is red, and vice versa. French Roulette affords seven chances; comprising that of the numbers, and the latter chance divides itself into many others, of which we shall give a brief detail. The player stakes upon the chances. He may select pleases, or that the banker allows. The player who puts his money on one of the numbers or the zeros painted on the green cloth, receives thirty-five times the amount of his stake should the ball fall into the corresponding number or zero in the interior of the roulette. The player who plays on the numbers, may play the first twelve, the middle twelve, and the last twelve. If the ball enters one of the twelve numbers corresponding to those on the green cloth on which the player has staked his money, he is paid three times the amount of his stake. To play the Colonnes, the player stakes his money in the square placed at the foot of each column marked on the green cloth; and in the event of the ball entering one of the holes corresponding to the numbers of the column, he wins three times his stake.

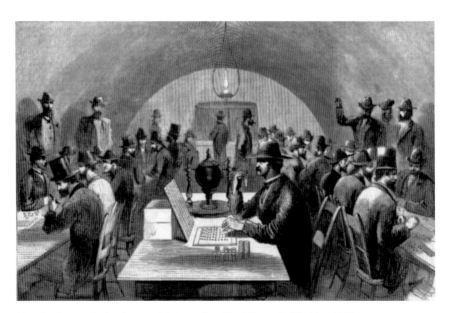

Sketch of men playing keno, with the caller. *From* Harper's Weekly, *1867.*

Again, he may equally, at his pleasure, play two, three, four, six numbers, and he wins and loses, in the same proportion, eighteen times his stake for two numbers, twelve times for three numbers, nine times for four numbers, and six times for six numbers, and the rest in proportion. The player who may have put his money on one or the other of the six chances, wins double his stake, if the chance arise. If, then, a ball enter a hole, of which the number is 36, the banker pays double all the following chances, passe, pair, and rouge, and likewise thirty-five times the amount of the sum staked upon the number THIRTY-SIX, and of course draws to the bank all the chances placed on the other chances.[26]

If the ball enter a hole numbered 18 noir, the banker pays the player double the amount of the stakes placed on the following chances, la manque, l'impair, and noir, and thirty-five times the amount of the stake placed upon the number 17, and draws to the bank all the money placed on the other chances.[27]

Of all the games of chance, Roulette is unquestionably the most unfavorable to the player, for the bank's mean chance of winning is or nearly 8 per cent on a single number. Nearly 6 1/2 per cent on either of the 12 numbers, or the colonnes. Nearly 5 per cent upon two numbers. Nearly 63 per cent upon three numbers. Nearly 7 per cent upon four numbers. Nearly 7 per cent upon six numbers. Nearly 5 per cent upon the passe, pair, manque, impair, rouge et noir. And hence it is against the player upon the 1st chance: 37 to 1, 2nd 13 to 6, 3rd 18 to 1, 4th 113 to 1, 5th 17 to 2, 6th 16 to 3, and 7th 10 to 9.[28]

When, however, the numbers are all filled up, as the bank only pays the winner thirty-five times his stake, it clears three; thus, supposing thirty-eight dollars to be staked, and that the ball is thrown twice in a minute, the gain of the bank, without incurring the slightest risk, would be six dollars per minute, or three hundred and sixty per hour. Although, in whatever way you play, the chances are always in favor of the bank, still its risk varies in ratio to the number of chances which are not filled up; for instance, were only ten numbers filled up, and that the ball were to enter one of them, the bank would, in that case, lose thirty-four, and only win eight; whereas, when all the numbers are filled up, it wins three, without risking a cent. The single and double zeros are bars, where stakes are placed upon the colors. When the ball enters the single zero, all bets upon the black neither win or lose, because the figure is painted black, and the same rule applies to the double zero.[29]

FRENCH ROULETTE TABLE.

Illustration of the French roulette table from *"Trumps," The American Hoyle, Or, Gentleman's Hand-Book of Games: Containing All the Games Played in the United States, with Descriptions, and Technicalities, Adapted to the American Methods of Playing.* Dick & Fitzgerald Publishers, New York.

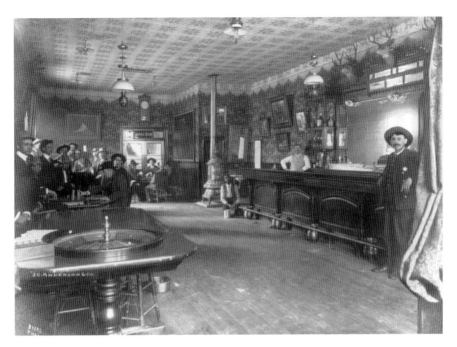

Scenes of open gambling in Reno, Nevada: roulette wheel at left, bar at right, October 8, 1910. *Library of Congress.*

The American roulette table is played the same as the French roulette just described but was more common among sporting men preferring a twenty-eight to a thirty-six table, because its percentage against the player is much stronger. In French or thirty-six roulette, the single 0 and 00 are sometimes bars; but in a twenty-eight, the single 0, double 00 and eagle are never bars; but when the ball falls into either of them, the banker sweeps everything upon the table, except what may happen to be bet on either one of them, when he pays twenty seven for one, which is the amount paid for all sums bet on any single figure.

> *The odd figures are painted black, and the even red, and as they are equal in number, all bets made upon black or red are paid even, i.e., dollar for dollar. All bets made at the foot of a column are paid three for one; other divisions are marked off upon the cloth, embracing a certain number of figures, for which eight for one is paid, and for all bets placed upon any single figure, or upon the single 0, double 00, or eagle, twenty-seven for one are paid. The money bet must be placed upon the figure or place selected before the ball moves, or has ceased to roll.[30]*

Horsracing was also popular during the Civil War in Louisville. During 1860 and 1861, the Woodlawn Race Course, which was situated six miles east of the city, held both spring and fall meetings, offering purses from $200 to $500, which is equivalent to $6,734 to $16,835 today. The purses paid at the Woodlawn Racecourse were uncommonly large for the period, and many horses from the surrounding states were brought to Louisville to compete for the prizes. The races were run according to the rules of the course, and all jockeys, who were African Americans, were required to wear the distinctive garb of their calling. At the spring meeting of 1861, the *Louisville Journal* reported that the crowd was large, "with both sexes present, and the betting was heavy." After 1862, however, the meetings were suspended and no regulation meets were held until after the end of the war. But even though there were no formal meets in the city, the city did hold an occasional day of racing, offered to the gambling public during the summers of 1863 and 1864.[31]

THE GOLDEN AGE OF GAMBLING IN LOUISVILLE: 1860–1885

After the Civil War, steamboats and railroads became a major part of the city's economy. During the Gilded Age, which lasted from 1870 to 1900, Louisville became an important city in industry, trade and commerce. Louisville had the introduction of new railroads, the extension of the old ones, the bridging of the Ohio River, the improvement of the Portland canal and river navigation, the introduction of modern methods in every sector of business life and the erection of buildings devoted to commerce; manufacturers and domestic purposes were all contributing factors in Louisville becoming an industrial city.[32] Louisville's top products in industry, trade and commerce were tobacco and whiskey-bourbon. Other top industries were plows. To feed the South and West's needs for new technology in farming, Louisville became the largest manufacturer of plows in the world. To help build the new infrastructure, the country needed cement. Louisville provided that need with the best cement in the country. The new infrastructure also needed pipes, and Louisville became the nation's leader in producing cast-iron pipe for water and sewers for the ever-growing cities. Louisville also led the country in jeans and wool cloth production. Louisville also made wagons, valises and trunks, chocolate, boilers, tinware, shoes and lumber. Louisville also made newspaper and

AMERICAN ROULETTE.

8 for 1	8 for 1	8 for 1	8 for 1
28	27	14	13
26	25	12	11
24	23	10	9
22	21	8	7
20	19	6	5
18	17	4	3
16	15	2	1

Red.　　　　　　　　　　　Black.

0 0	Eagle.	0

Black.　　　　　　　　　　　Red.

0	Eagle.	0 0

1	2	15	16
3	4	17	18
5	6	19	20
7	8	21	22
9	10	23	24
11	12	25	26
13	14	27	28
3 for 1	3 for 1	3 for 1	3 for 1

AMERICAN ROULETTE TABLE.

Left: Illustration of the American roulette wheel in *"Trumps," The American Hoyle, Or, Gentleman's Hand-Book of Games: Containing All the Games Played in the United States, with Descriptions, and Technicalities, Adapted to the American Methods of Playing. Dick & Fitzgerald Publishers, New York.*

Below: Men gambling (playing cards and other games) in a saloon, circa 1910–20. Note the roulette wheel in foreground on left; the sheriff, on right, leans against the bar. *Library of Congress.*

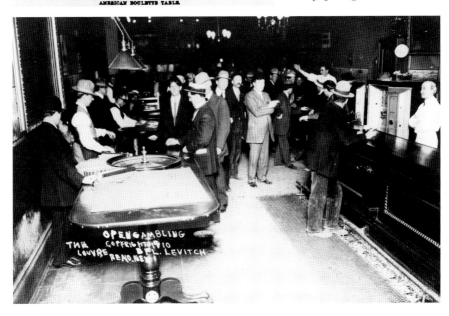

wrapping paper. Three large plants in Louisville were involved in artificial fertilizers. Paints, colors and varnishes were a large and rapidly increasing industry. In millwrighting, copper and brass work and wire works were also growing industries. Louisville produced pickles and cider vinegar, chewing gum, patent medicines, plumbers' supplies, brooms, monuments, stonework, vitrified brick, fire brick and paving materials, terra-cotta and clay sewer pipe, electrical and surgical instruments, steel and wood single trees and neck yokes All of these were thriving industries in Louisville. One thousand people were involved in the publishing, lithographing, binding, electrotyping, manufacturing stationery and paper boxes business.[33]

With the advent of railroads, Louisville had a cheap and easy communication with all the important points in the continent. Louisville had connections with the North, South, West and seaboard cities. The L&N purchased the majority of stocks in other railroads, such as the Nashville, Chattanooga & St. Louis railway system, the Owensboro & Nashville Railroad and the Mobile & Montgomery Railroad. It leased the New Orleans & Mobile Railroad and the Pontchartrain Railroad. It also leased the southern division of the Cumberland & Ohio Railroad and the Indiana and Illinois division of the St. Louis and Southeastern Railroad, the Selma division of the Western Railroad of Alabama. L&N purchased the Pensacola Railroad and the Pensacola & Selma Railroad. In 1885, the L&N had control of 2,027 miles of track and transported 569,149 people.[34]

Steamboats and railroads brought passengers from all over the country to the city of Louisville, which continued to expand the gambling houses. With the newfound wealth in Louisville, wealthy industrialists and financiers were able to indulge in the ever-expanding gambling houses. There were grand gambling palaces furnished with black oak and velvet furnishings, where only the elite gentlemen were allowed to play high-stakes games. Even the average man could play at "sawdust pavilions," where anyone's money could play.[35] After the Civil War, race horsing reemerged, and with the abolition of slavery, the game changed from sport for the wealthy aristocracy of the South into a game of gambling for everyone to participate.

In 1874, the Louisville Jockey Club was organized at Churchill Downs, and the first meeting of the Board of Directors was held on October 2, 1874. The directors were R.A. Newhouse as treasurer, E.H. Chase as treasurer, J. Caldwell, Joel Womack, Thomas Jacob, John Green, Meriwether Lewis Clark, Luke Blackburn, T.J. Martin Jr., Major W.H. Thomas, J.W. Hunt

Louisville & Nashville Railroad

THE GREAT

SHORT LINE

BETWEEN

ST. LOUIS, NASHVILLE, CHATTANOOGA, ATLANTA,

AND ALL POINTS SOUTHEAST

It is the only direct **THROUGH ROUTE** to Decatur, Birmingham, Montgomery, and principal cities in the South.

IT IS ALSO THE

SHORTEST AND QUICKEST ROUTE

To St. Louis. Connections are made at Louisville for Cincinnati and

ALL EASTERN CITIES.

This Line has no Superior; it is acknowledged to be the

FAVORITE LINE TO FLORIDA

Through Tickets are always on sale at the Ticket Offices throughout the West and North. Enquire for them over the Louisville & Nashville R. R., the reliable line to and through the Southern States. The line is equipped with Elegant Parlor Cars for day trains, and Pullman Palace Sleeping Cars for the night trains.

C. P. ATMORE,

Gen'l Pass. & Tkt. Agt., Louisville, Ky.

Advertisement of the Louisville & Nashville Railroad Short Line. *From the* Kentucky State Gazetteer and Business Directory 1883–1884, *vol. 4, R.L. Polk and A.C. Danser, Detroit, Michigan, Louisville, Kentucky.*

J., M. & I.
RAILROAD.

LOUISVILLE and INDIANAPOLIS SHORT LINE

THE DIRECT ALL RAIL ROUTE TO ALL POINTS

NORTH, EAST and WEST.

ST. LOUIS, CHICAGO, CLEVELAND.

THREE DAILY EXPRESS PASSENGER TRAINS FROM LOUISVILLE, WITH THROUGH SLEEPERS TO

Only One Change to Boston.

BUFFALO, ALBANY, NEW YORK.

QUICKEST AND CHEAPEST ROUTE TO

KANSAS CITY, ST. JOSEPH,
OMAHA, DENVER, DALLAS,
SHERMAN, HOUSTON, GALVESTON,

AND ALL POINTS IN TEXAS.

FREIGHT BILLED THROUGH AT LOWEST RATES TO ALL POINTS, NORTH, EAST AND WEST.

Principal Offices cor. Third & Main Sts.,
LOUISVILLE, KY.

| E. W. McKENNA, | R. W. GEIGER, | H. R. DERING, |
| Superintendent. | Gen'l Freight Agent. | Gen'l Pass. and Ticket Agt. |

Advertisement of the Louisville & St. Louis Railroad. *From the* Kentucky State Gazetteer and Business Directory 1883–1884, *vol. 4, R.L. Polk and A.C. Danser, Detroit, Michigan, Louisville, Kentucky.*

Louisville and St. Louis

AIR LINE.

Louisville, Evansville & St. Louis

RAILWAY.

The Only Line between Louisville and Evansville, Ind.
The Only Shortest and Best Route between Louis-
ville and Owensboro, Ky., and Louis-
ville and Henderson, Ky.

56 Miles the Shortest

TO

ST. LOUIS AND THE WEST

Two Double Daily Trains between LOUISVILLE
and ST. LOUIS, with

PULLMAN PALACE SLEEPING CARS,
PULLMAN PALACE PARLOR CARS,
NEW AND ELEGANT DAY & SMOKING CARS,
AUTOMATIC BRAKES.

Are run through without Change of Cars of any class.
Be sure your Tickets read via the Air Line.

W. SNYDER,
General Manager.

JAMES S. CARK,
Gen'l Freight and Ticket Agent.

Advertisement for the J.M. & I Railroad. *From the* Kentucky State Gazetteer and
Business Directory 1883–1884, *vol. 4, R.L. Polk and A.C. Danser, Detroit, Michigan,
Louisville, Kentucky.*

MONON ROUTE.

Louisville, New Albany & Chicago

RAILWAY.

THE ONLY LINE under one management between Louisville and Chicago.

THE ONLY LINE running its **entire Trains** (Passenger and Freight) from Louisville to Chicago without change.

THE ONLY LINE running Pullman Palace Sleeping Cars from Louisville to Chicago.

THE ONLY LINE from Louisville to Greencastle, Crawfordsville, LaFayette, Michigan City and Chicago, without Change of Cars.

THE MOST DIRECT ROUTE

TO ALL POINTS IN

Illinois, Michigan, Iowa, Kansas, Nebraska

AND

ALL POINTS WEST.

Tickets via the "MONON ROUTE" can be purchased at all Railroad Ticket Offices South.

FOR FURTHER INFORMATION AS TO RATES, TIME, &c., ADDRESS

MURRAY KELLER, Gen'l Pass. Agent, Louisville, Ky.

E. B. STAHLMAN, General Traffic Manager.

H. B. SMITH, Gen'l Freight Agent, Chicago, Ill.

Advertisement of the Louisville, New Albany, & Chicago Railroad. *From the* Kentucky State Gazetteer and Business Directory 1883–1884, *vol. 4, R.L. Polk and A.C. Danser, Detroit, Michigan, Louisville, Kentucky.*

Reynolds, General E.H. Murray, H. Newcomb, D. Swiggert, A.D. Hunt, J.R. Butler, A.D. Hunt, J.R. Butler, C.C. Rufer and John Churchill. There were 195 stockholders. The president was Colonel Meriwether Lewis Clark. Director Hunt, who was married to Sallie Ward Hunt Armstrong Downs, had just died, and Colonel John Churchill, who was the next largest stockholder in the club and represented the heirs who owned the property where Churchill Downs was located, was elected director. The first Kentucky Derby was run on May 17, 1875, and conducted the first running of a new stakes race. The Kentucky Derby was the showpiece of the new approach to horse racing. A $1,000 purse was given to the winner of the three-year-olds. On opening day, over ten thousand people attended the new track, which was the largest for any opening of a new track or the first running of a new stakes race. Aristides won the first Kentucky Derby.

The club had nineteen derby races from 1875 to 1894. Although such horses such as Hindoo, Leonatus, Montrose, Spokane, Riley and Kingman became famous, the track gradually and continually lost money, and in 1893, the track was bankrupt. On August 7, 1894, the Louisville Jockey Club filed for bankruptcy. The club owed $10,000, which is the equivalent to $339,979 today. The largest stockholders held a meeting and agreed on a plan of action. The New Louisville Jockey Club was made an assignee. The purchasers were W.F. Schulte, W.E. Applegate, Henry Wehmhoff, George Gaulbert, Emil Bourlier, Buch Schell, Colonel M.L. Clark and many others, with shares set at $100 each. The capital stock was set at $80,000. The club spent $80,000 on improvements, and the old grandstand near the Fourth Street trolley car line was torn down. A new brick and steel stand was built on the Seventh Street side of the track so the afternoon sun would not interfere with the spectators in the stands. The president of the new track was Colonel Clark, with officers Emil Bourlier, W.E. Applegate, Henry Wehmhoff, Charles Bolinger and W.F. Schulte. In the spring of 1895, the first derby race took place in the new Jockey Club, and Halma won the race.[36]

Early trackside betting at Churchill Downs changed from auction pools, to bookmakers, to pari-mutuel machines. A pari-mutuel machine is a machine for performing calculations automatically. In 1867, Joseph Oller invented the pari-mutuel system. Pari-mutuel betting is a betting system in which all bets of a particular type are placed together in a pool, in which taxes and the "house-take" or "vigorish" was deducted and payoff odds are calculated by sharing the pool among all winning bets. The large number of calculations involved in the system led to the invention of a specialized

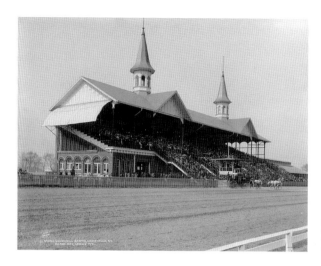

Churchill Downs Derby Day, 1901. *Library of Congress.*

calculating machine known as a totalisator, automatic totalizator or "tote board," which was invented by Australian engineer George Alfred Julius. By 1908, bookmakers had become illegal. Colonel Meriwether Lewis Clark, the founder of Churchill Downs, imported the pari-mutuel machines from France to eliminate dishonest bookkeepers. Kentucky was the first state to legalize the new betting machine, and Louisville produced the first American-made pari-mutuel device, which was created by Charles Grainger's iron foundry.[37]

During the golden age of gambling in Louisville, all of the north side of Jefferson Street from Fourth to Fifth Streets, all of the east side of Fifth Street from Jefferson to Market Streets and almost all of the west side of Market Street, from Fifth to Fourth Streets, were gambling houses. The businesses were the Richmond, located Fifth and Market, on the southwest corner, which was a faro bank; the Headquarters, which was a faro bank near Market Street, between Fourth and Fifth Streets; Number 80, which was located on Fifth Street near Market; The Bank, which was located at Jefferson Street near Guthrie Street; No. 27 on West Jefferson Street; No. 161 on Fourth Street and Fifth and Jefferson, in the Crystal Palace; the Old Kentucky Club, located below the Knickerbocker, on Jefferson Street, a keno house; Number 102, which was located near Fifth Street; and The Silverlake, which was located on Jefferson Street, between Fourth and Fifth Streets.[38] Nearly every corner in the city's central district had a gambling hall, and the old Green Street (now Liberty Street) contained rows of gambling houses.[39]

During that time, faro, keno, chuck-a-luck and roulette were the most popular games, with faro banks and chuck-a-luck games being played by

devoted followers. During the early 1880s, the first craps game in Louisville was played by African Americans at Tenth and Broadway, which was owned by Bill Mann. Several years later, white residents began to play the game, and soon most of the gambling houses in Louisville were offering it. From 1860 to 1885, there were eighteen gambling houses in the city, along with smaller game rooms, which were run by the hotels. Two of the most popular gambling houses were the Beargrass Club, located on the south side Jefferson Street, between Fourth and Fifth Streets, and the Officers Club, which was located on Main Street between Fourth and Fifth Streets. The Beargrass Club was frequented by only the wealthiest and most prominent men of Louisville and the surrounding area, along with the wealthy and social elite from other sections of the state who visited the city. The stakes were the highest pay of any gambling houses in America, except for New Orleans.[40]

Greeting the visitors to the Beargrass Club and the Officers Club were handsomely dressed footmen to assist the visitors and keep out the undesirables. The Officers Club was for the military officers, although

Advertisement of the Crystal Palace. *From the* Kentucky State Gazetteer and Business Directory 1883–1884, *vol. 4, R.L. Polk and A.C. Danser, Detroit, Michigan, Louisville, Kentucky.*

the club did allow patrons who were fortunate enough to have admission cards. Social status and the ability to pay the dealer were the conditions of membership to the exclusive club. The Shades gambling house, on the southwest corner of Fourth and Green (now Liberty) Streets, and the Hotel De Raines on Main Street between Third and Fourth Streets were ranked just below the Beargrass and Officers Clubs.[41]

Two Englishmen, one of them by the name of "English Billy," aka William Reynolds, made their fortunes by running the Union blockade during the Civil War with Southern cotton intended for English markets and after the Civil War opened the Idle Hour, which was located at south side of Main Street between Third and Fourth Streets. Reynolds personally "banked" all the games. Their gambling halls rivaled the salons of a Turkish sultan. African American waiters served the choicest drinks and the most elegant food. There were luxurious lounging and smoking rooms, and the players sat in large leather chairs in front of tables made from mahogany. The play had no limit. Unfortunately, the Idle Hour lasted only a short time due to the losses of $1,200,000 in eighteen months, which is the equivalent to $29,229,600 today.[42] On December 20, 1883, Reynolds died of pneumonia. He lived on a farm in the French settlement in New Albany, Indiana, and did business mostly under the direction of infamous gambler and casino owner Anderson Waddell.[43]

The Walker's Exchange ran for ten years and was located on the west side of Third Street, between Main and Market Streets. Gold passed across the tables every day. The building took up the space of five regular buildings, and in addition to the gambling rooms upstairs, there was an immense bar downstairs. Most of the gambling houses had saloons downstairs, with the games being played on the second or third floors or sometimes both. In 1879, Edward Hughes, who was Louisville's Fire Department chief, and James "Dick" Watts bought Walker's Exchange. They added a poolroom and changed the name to the Turf Exchange. The firm was known as J.R. Watts & Company and was ranked one of the most popular pool sellers in the country. Some of the heaviest "plungers," also known as gamblers, in the country sat listening to auctioneers Bob Cathcart and Joe Burt. In one season, the pools generated $1,500,000, which is the equivalent to $29,229,600 today. The house made over $100,000 (or $2,231,267 today) in profits. The firm became known as Hughes, Cathcart & Company. In 1883, Watts left the firm, and the company became known as Hughes & Cathcart. In 1886, Hughes and Watts sold the building to Henry Wehmhoff and Emile Bourlier,

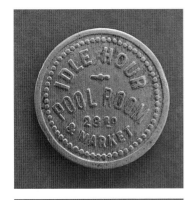

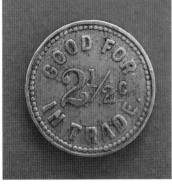

Top: Reverse of the Idle Hour token. *Author's personal collection.*

Bottom: Idle Hour Token. *Author's personal collection.*

who combined the Turf Exchange and the Jockey Club poolrooms and kept the name Turf Exchange.[44] Emile Bourlier started the Louisville Jockey Club poolroom. Eventually, Bourlier closed the Jockey Club because of the laws that were passed against gambling. The business continued to operate as an auction selling pools on the New Orleans horse races. Frederick Bishop remained manager of the Turf Exchange, Joe Burt remained as auctioneer, and they set up a bookmaking enterprise in Memphis. The Turf Exchange ran until 1906, when raids put a stop to the illegal activity.[45]

James "Dick" Watts owned the Crockford, which was the most spectacular of all the gambling houses in the city. The gambling house was located on the south side of Jefferson Street, below Fourth Street, and had three two-story buildings with a large court in the center. The building's previous owner was Anderson Waddell, who was the most famous of the gamblers. When Waddell left Louisville, he settled in Nashville, Tennessee, and sold the business to Watts for a fortune. Watts made back all the money he had spent on buying the business. Riverboat gamblers who played among the passengers on steamboats between Louisville and New Orleans traveled to Louisville, and each Saturday night a crowd of riverboat gamblers walked into the Crockford to match their skill against one another. The gamblers played only stud poker, and the bets could be as high as $75,000 ($2,222,332) stacked high on the table. Watts's business became so popular that in 1872, he had to expand and built a keno gambling casino, which comprised three stories. Watts posted flyers and published advertisements in the papers with pictures of the interior and exterior of the building, announcing the grand opening. In July 1885, the Palais Royal was raided, and the gambling furniture was removed. On August 25, 1885, Watts's casino was raided, and his manager, Captain C.S. Jenks, was

J. R. WATTS. ROBT. CATHCART, JR. ED. HUGHES.

WATTS, HUGHES & CATHCART,

TURF EXCHANGE

POOL SELLERS & BOOK MAKERS,

247 THIRD STREET,

(Old No. 81.) LOUISVILLE, KY.

JOCKEY CLUB
POOL ROOM

POOLS SOLD ON ALL

Legitimate Sporting Events

BOURLIER & CO.,

235 THIRD AVENUE,

LOUISVILLE KENTUCKY.

Left: Advertisement for the Turf Exchange. *From the* Kentucky State Gazetteer and Business Directory 1883–1884, *vol. 4, R.L. Polk and A.C. Danser, Detroit, Michigan, Louisville, Kentucky.*

Right: Advertisement for the Jockey Club Pool Room. *From the* Kentucky State Gazetteer and Business Directory 1883–1884, *vol. 4, R.L. Polk and A.C. Danser, Detroit, Michigan, Louisville, Kentucky.*

arrested and paid a $600 fine, but all the gambling equipment was taken. In September 1885, the famous keno casino Palais Royal was raided again and the equipment removed.[46]

The previous owner of the Crockford was Nellis Borden, who ran the business as a saloon, with a variety theater attached to the building known as the Knickerbocker. Early in the 1880s, Major Edward Hughes and Colonel James "Dick" Watts bought the business and changed the name to the Crockford after a prominent turfman. Soon after, Colonel Anderson Waddell, who was one of the wealthiest players of the games in the city, took an interest in the business and bought one-third and opened his business on the second story. The Crockford offered the game of faro exclusively, and the center of the courtyard was where a player could play four games at once, such as faro, roulette, faro bank and chuck-a-luck. Waddell gave strict rules to his dealers, stating that they could not play the game with the patrons and would dismiss them immediately if his rule was broken. Saturday mornings was the only time dealers could play with the patrons, and the game was faro. Waddell personally dealt the cards and won back all the wages he had paid the employees just hours before. With outside patrons, Waddell had a rule that if he "broke" a man completely, he would pay him back a percentage of his losses and ban the patron from the club.[47] During the 1860s and 1870s, gambling was at the peak in the city. Early in the 1880s, Churchill Downs had one week in the spring and one week in the fall for racing, and the events drew people from all over the country. The great gambling houses

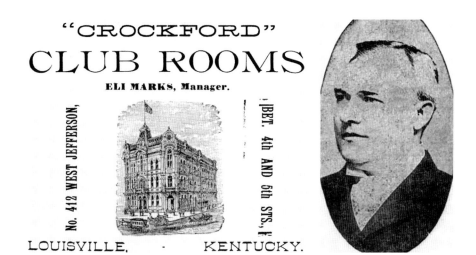

Left: Advertisment for the Crockford Club Room. *From the* Kentucky State Gazetteer and Business Directory 1883–1884, *vol. 4, R.L. Polk and A.C. Danser, Detroit, Michigan, Louisville, Kentucky.*

Right: Pat Sheedy, famous gambler. *From the the* Boston Globe, *May 26, 1902.*

such as the Crockford hosted the visitors. During the races, faro was at the game's height. Colonel Waddell placed Eli Marks and Black Dent in charge of the games.

During a spring meet of the Louisville Jockey Club, Pat Sheedy stopped by the Crockford and won $7,000 ($170,000). Sheedy was a gambler with a national reputation. During another spring meet, three well-dressed strangers entered the Crockford and won $5,000 ($141,000 today), after which they left the establishment. One day, Clark Adams, who was a noted riverboat gambler, entered Waddell's establishment, and at the time Waddell was dealing the faro cards personally. Adams stated he had $1,250 ($46,842 today) and asked Waddell if he wanted to bet the entire sum of money on the ace to win. Waddell agreed, and the ace won, paying Adams $2,500 ($56,547 today). Adams looked at Waddell and said, "Do you want it again?" Waddell answered yes, and the ace won again and took $5,000 ($141,858 today). Again and again Waddell took the bet, and again, against all odds, the ace won two more successive times. Adams had won $20,000 ($592,622). In a few seconds, Waddell lost $17,000 ($503,728), but the "bank was not broke."[48]

Waddell also owned several other gambling houses. He owned an establishment on Main Street below the Louisville Hotel. Waddell

employed Bill Richardson for several years on a small salary. Richardson had previously driven a stagecoach in southwestern Kentucky. He watched the dealers at Waddell's gambling house, and one night he walked in with $5 and won money. The next day, he put together his winnings from the previous day and played again and again and won every time. For three weeks, he kept playing until he had won $30,000 ($888,933). With his winnings, he bought his daughter a farm near Hopkinsville, Kentucky. As with many gamblers before him, he did not know when to quit and lost all of the money he had won and died poor.

Jack Haverly lost $20,000 ($592,622) in a twenty-four-hour period at Waddell's gambling house. Haverly was in Louisville with his minstrel show and stopped in Waddell's gambling house. He lost his first game right from the start, and at 2:00 p.m. the next day, he got up from the table and left a note stating he owed $20,000 ($592,622). In April 1885, the city declared war on the gambling houses, and the Crockford, along with other gambling houses, closed. From 1891 to 1893, a game house was established after the repeal of the law, and poker was played at the Crockford. The last occupants of the Crockford were Sweeney and Walker. Pat Sweeney, the senior member of the Crockford, owned several barrooms in Louisville. After the death of her husband, Rebecca Waddell, who owned the building, resided on a plantation left in her husband's will. In 1901, the Crockford finally came to an end when an explosion in the basement of a photographic supply house a block away on 412 West Jefferson. Although the explosion did not harm the Crockford, the photographer supply shop needed to rent the "sample" room, concert hall and gambling apartment for its business. Mrs. Anderson Waddell did not renew the lease for the saloon and instead gave the lease over the photographic company and building was taken down and remodeled.[49]

In 1877, the first poolroom was Parmele's, which opened on Fourth Street, near Main Street, where only auctions and mutuels were sold. The first big poolroom in Louisville was opened by Waddell and Joe Burt on Third Street between Main and Market Street, and a single bet of $10,000 ($290,500) could be waged on a horse race. Poolrooms were a method of gambling in which all money bet on the result of a particular event by a number of people was awarded to one or more winners according to conditions established in advance—other charges may be deducted from the total pool before prizes are awarded. Pool selling was introduced in the nineteenth century, and the pool method of dividing the wagered total between the winners spread to practically every country in the world and formed the rational basis for

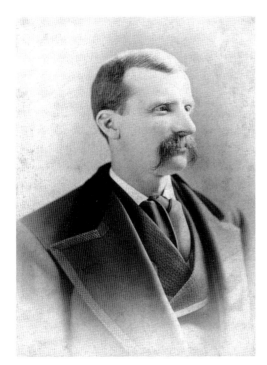

Left: Jack Haverly. *University of Washington Special Collections, Digital Collection, J. Willis Sayre Collection of Theatrical Photographs, Accession Number 3630, 1894.*

Below: Advertisement for Haverly's United Mastadon Minstrels. *Stobridge Lithographing Company, Harry T. Peters "America on Stone" Lithography Collection Circa 1880, DL.Catalog number 60.2481 60.2481 Accession number 228146, Smithsonian Institution.*

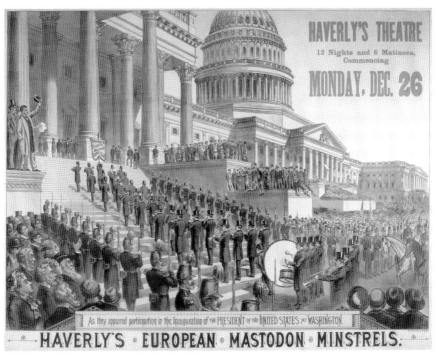

Advertisement for Haverly's United Mastadon Minstrels. *Stobridge Lithographing Company, Harry T. Peters "America on Stone" Lithography Collection Circa 1880 DL. Catalog number 60.2482, 60.2482 Accession number 228146, Smithsonian Institution.*

running nearly all modern lotteries as well as most organized betting on horse racing and other professional sports.

In 1869, Major Ed Hughes and James "Dick" Watts bought the Walker's Exchange and in 1876 changed the name to the Turf Exchange. The Turf Exchange was under the name of Watts, Hughes, & Cathcart. The business was sold to Henry Wehmhoff and Emile Bourlier. In 1881, the Kentucky Derby was started by Lew Fredericks but was short-lived. Two years later, Emile Bourlier opened the new Jockey Club, which was a poolroom. Waddell took an interest in the Jockey Club, and when the business became successful, Anderson Waddell and Joe Burt opened another casino called Newmarket, which was located between Main and Market Streets. The Turf Exchange and the Newmarket were the two houses where local bettors could bet thousands of dollars on a horse race. The two houses had a monopoly on turf betting. Waddell was the mastermind of the sporting fraternity of Louisville.[50] Waddell's cashier was a young man named Madison Cawein, who became Kentucky's

greatest poet. Nat Goodwin, an actor famous for his performances in *Oliver Twist* in 1912, *Business Is Business* in 1915 and *The Marriage Bond* in 1916, lost $150,000 ($4,357,514) in Louisville gambling houses during a period of seven years.

Bob Gray, operator of the famous gambling house at the Rufer's Hotel on Fifth Street near Main Street, collected $8,000 ($232,400) from Goodwin. Rufer's was known for hospitality and high stakes. According to one story, Goodwin had just performed at MacCauley's Theater and sat in during one of Gray's games and lost $5,000 in cash, which is equivalent to $275,000 today. The amount of money lost was the size of his and his manager's bankroll put together. Gray was willing to accept "markers" from Goodwin, and

Nat Goodwin. *Nat Goodwin, Nat Goodwin's Book,* Gorham Press, Toronto: Copp Clark Company Limited, 1914.

Goodwin continued to bet until the early morning hours, ultimately owing $20,000 to Gray. Goodwin left and promised Gray he would pay him back. When Gray did not receive any payment, he wrote to Goodwin asking for payment of his debts. Goodwin sent $10,000. Gray heard that Goodwin might leave for Europe, so he made his trip to New York and arrived just as Goodwin was boarding a ship. Goodwin and his friends managed to put together $8,000 to pay Gray, along with a note stating that a wealthy friend would send Gray the remaining $2,000. Gray went ahead and let Goodwin board his ship.[51]

For horse racing, the Jockey Club, the Ascot, the Sulurian on Fourth Street, Payne's & Company and the Suburban brought prominence to men such as Henry Wehmhoff and Charlie Bollinger, but the Turf Exchange and the Newmarket were the premier poolrooms.[52] Charlie Bollinger, Henry Wehmhoff and Colonel William E. Applegate bought $200,000 of stock in the Latonia racetrack, which was located in Covington, Kentucky, and opened in 1883, which made them owners of 51 percent of stock in the track. Wehmhoff sold his interest in the track to Bollinger and Applegate, but both men sold their interest in the track in 1900 to Judge George G. Perkins of Covington. Applegate stated they lost money in the track and were glad to be rid of it.[53]

RUFER'S HOTEL
AND
RESTAURANT.
(EUROPEAN PLAN.)
Fifth Street, bet. Main and Market,
LOUISVILLE, KY.

The Most Elegant SLEEPING APARTMENTS and SAMPLE ROOMS in the City.

☞ I have also opened, adjoining my Hotel and Restaurant, **A RETAIL WINE AND LIQUOR STORE**, where I will keep the Choicest Brands of Wines, Brandies, Imported and Domestic Ales and Porter, and the Oldest and Best of Kentucky Whiskies.

C. C. RUFER, Proprietor.

Top: Illustration of Rufer's Hotel. *From* The Industries of Louisville, Kentucky and of New Albany, Indiana, *J. M. Elster and Publishers, Louisville, Kentucky, 1886.*

Bottom: Advertisement for Rufer's Hotel. *From the* Kentucky State Gazetteer and Business Directory 1883–1884, *vol. 4, R.L. Polk and A.C. Danser, Detroit, Michigan, Louisville, Kentucky.*

During the golden days of gambling houses in Louisville, there were several hundred buildings used exclusively for gambling. Some of the other gambling houses were the Palais Royal, which was located on 416 West Jefferson Street. The Pearl was located on the northeast corner of Fourth and Green Streets (now Liberty), which was on the corner opposite the Old Opera House. The Pearl was one of the first Civil War establishments opened by James Cornell. The Richmond Hotel, which was located on the corner of Fifth and Market Streets, was open only for private games. The Rider's Hotel, which was located on Gray Street, and Phil German's Hotel also catered solely to

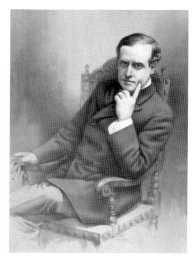

Nat Goodwin, 1889. *Library of Congress.*

private games. The famous Galt House had the Southern Club and was open only to private high-end poker. The Silverlake, located below the Masonic Temple on Fourth Street, was another of the gambling casinos.

By 1885, Louisville was known as the "City of Gamblers," "The Gambler's Paradise" and "The Monaco of America."[54] Nowhere else in the South or West short of the Pacific coast were there so many transactions. There was no place in America where gambling of all kinds was carried out more openly. For three square blocks on Fifth Street and four squares on Jefferson Street, nearly every house was filled with keno rooms and faro banks. Louisville became the horse racing center of the state. Church members bought pools on races and bet on every election, including state, city and national. There were lottery shops, keno, faro and poker rooms. The Jockey Club had the finest track in the South and brought thousands of visitors to every spring and fall meet; hundreds of thousands of dollars changed hands. James "Dick" Watts, who was one of the owners of the Turf Exchange, took bets by telegraph and had French mutuels and pool selling, and his sales amounted to $6–7 million, which is equivalent to $180,801,649 today. On Derby Day 1885, $200,000 changed hands on the grounds of Churchill Downs alone—all in cash. The amount of money that could be won at the derby was "breathtaking" at the time. Colonel "Black" Jack Chinn won $35,000 ($1,026,820 today) on his horse Leonatus. In a poker game with some Kentucky turfmen, Chinn won $15,000 ($440,065 today).

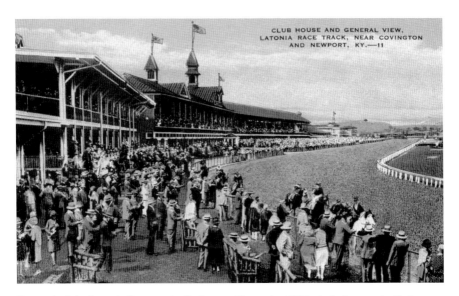

Postcard of the Latonia Racetrack, Covington, Kentucky, 1901. *Author's personal collection.*

Another turfman was Mike Keegan. He won $40,000 on Lida Stanhope. He was one of the heaviest "plungers" or gamblers and was worth $200,000, which is the equivalent of $6,026,721 today. Even children bought pool tickets. On one side of Third Street, a well-dressed man would wager thousands of dollars at the Turf Exchange, and across the street, newspaper boys and shoe shiners bet quarters on the derby. The judge of the circuit court bought pools. Chief of the Fire Department Ed Hughes sold pool tickets across the counter, and the lead councilman of the city was an auctioneer during the races. The governor of Kentucky bought pools. Girls bought pool tickets and divided their pocket money with their brothers and tried their luck to have a winner. Men made fortunes in only a couple of years. Milton Young, a grocery store owner who lived in Henderson, Kentucky, had a good horse and, after two years, bought himself a stock farm near Lexington. His famous McGrathiana was worth $200,000 to $300,000. His horses always lost at the right time and won at the right time.

Fourth Street became the "handsomest" street in the South. The Crockford had magnificent pictures on the walls, rich curtains in the windows and soft-pile Brussel carpets on the floors. Faro was dealt on inlaid tables of expensive wood and luxurious chairs. Across the street was a clubroom with a fashionable retail store, and customers were some of the boldest bettors in the United States. They played stud-horse poker. Hands were dealt in the usual manner except that one card is turned down and no player is allowed

The Finest and Largest Hotel in
the City.

RATES, $3.00 TO $4.00 PER DAY.

SPECIAL RATES FOR PERMANENT BOARDING.

THE NEW YORK HOUSE CO.,

PROPRIETORS,

Northeast Corner First and Main Streets,

LOUISVILLE, KY.

Advertisement for the Galt House.
From the Kentucky State Gazetteer
and Business Directory 1883–1884,
*vol. 4, R.L. Polk and A.C. Danser, Detroit,
Michigan, Louisville, Kentucky.*

to consult the card before betting. Phil German and Eli Marks thought nothing of losing or winning $10,000 at one game. As much as $40,000 could be seen on tables. Louisville gamblers were betting more recklessly than in any other American or European city. A number of small gambling houses or "hells" were common in the city and always packed. Major Ed Hughes made a fortune from the Turf Exchange and the Crockford and owned $100,000 of real estate. His clerk Emile Bourlier had $60,000 in gambling property. Jack Mellett, who was a councilman in the Tenth Ward, was a gambler. Phil Hinkle had two keno houses, although he was primarily a saloonkeeper. Major Ed Hughes and James Dick Watts were reckless players at their own games, and Watts once lost $15,000 on a single hand.[55]

The Jockey Club's fall and spring meets were gambling "carnivals." Almost every Kentuckian took an interest in the racing of the Thoroughbreds. Men knew the pedigrees and points on the horses. Kentuckians dropped everything to watch the horses on Derby Day. Immense sums of money were lost and won every day during the meets.[56]

In 1885, Anderson Waddell was one of the wealthiest gamblers in Louisville and owned a half interest in the Crockford and controlled four or five establishments. He never drank and seldom spoke. He killed three men in different altercations. The jury acquitted him in all three murders due to self-defense. On Jefferson Street in the heart of the gambling quarter was the home of naturalist John James Audubon. In the basement of the house was Reverend Steven Holcombe, one of the gambling princes of the South and the only man who was said to have a method of winning at poker. He traveled across America and traveled to Europe and made a fortune from gambling. He became a missionary later in life. He never told his secret on how to beat the game.[57]

THE GOOD TIMES COME TO AN END: 1885–1930

What finally brought an end to gambling in Louisville was a series of laws. The first of the attacks on gamblers was in 1876, when the grand jury indicted several gamblers and levied fines against those who owned tipping or disorderly houses, especially faro banks. Charles Savage, Andy Grainger, Gus Harrington and Henry Johnson paid a fine of $500 for having a faro bank, and Hugh Asa was fined $500 for running a keno bank.[58] In February 1885, the *Louisville Courier-Journal* began to attack the gamblers. The paper declared:

> *Suppress gambling by all means; fine it to the utmost limit of the law, but there is a law which says no man can be punished twice for the same offense, and from this prohibition gaming is not exempt. No doubt gambling is doing great injury to the community. Time and time again have we called attention to this state of affairs. The fault lies first with the courts and with the officers of the courts. We need a more rigid enforcement of the laws; justice swifter and more severe, and punishment, not for gamblers alone, but defaulting officers.*[59]

On July 1, 1885, every gambling house in the city of Louisville was raided. The Law and Order Club issued warrants to seize all gambling equipment at J.H. Dewitt & Company at the billiard saloon 336 at Green (Liberty) Street. Frank Beck and John Spanier had a keno house at 248 West Jefferson that was raided over the Paradise Saloon. The police arrested Mitch Lapalle, David Kuhn and Mike Leech. William Fleming and A.H. Harding were arrested at 312 and 314 Fifth Street. The Palais Royal was raided and Captain C.F. Jenkins arrested. Doors were broken down at the Palais Royal, and Ben Crutchfield was arrested. George Rapp, Henry Dent, Alex Besler, H.H. Warren and Hugh Asa were also arrested in the dragnet. Each paid the bond of $600. The police wagons were full of gambling tools, furniture and faro layouts.[60]

In August 1885, the Law and Order Club ordered the police to invade the keno bank of Jesse Hammond at 336 Green (Liberty) Street and the Palais Royal at Fourth and Jefferson, and all the furniture was taken out of the buildings. Chief John Whallen personally led the police on the raid. Hammond was arrested, and the goose balls, chips, tables and every piece of furniture were put on wagons and hauled away. An arrest warrant was issued for Captain C.S. Jenks at the Palais Royal. When the police raided

his gambling house, Colonel James "Dick" Watts came to the door and asked what the officers were doing at that time of night. He offered to go down to Central Station along with Captain Jenks. Bond was set for Jenks at $600; Watts paid the bond, and Jenks was released. The Palais Royal had been open only two months.[61] In November and December 1885, thirty-five gamblers were convicted and sentenced to forty-seven months imprisonment and a $16,000 fine, which was the severest penalty inflicted in any state in the United States.[62]

In 1886, the Law and Order Club ordered Emile Bourlier to close his poolrooms on Third Street and stop the selling of pools on horses. The Law and Order Club passed the Gambling Bill, essentially closing all the poolrooms in the city. John Baskin, who was the attorney for the Law & Order Club, stated that the organization planned to stop all betting, auction pools, combinations and Paris mutuels and intended to attack all forms of gambling. The Law & Order Club waged war on the pool sellers and gamblers. John Baskin and T.W. Moore swore out warrants and charged eleven well-known sporting men who ran the Turf Exchange and Jockey Club poolrooms. The arrest warrants were for Emilie Bourlier, E.B. Banks, Daniel Dowling, W. Boardman, Thomas Tucker, Henry Wehmhoff, Dave Durbin, Henry Pelty, Hal Dent, Samuel Bishop and Dave Kahn. All of them posted bonds. They were charged with keeping a disorderly house.[63] In February 1886, the Palais Royal gamblers Ben Crutchfield, Haten Warren, Alex Bosler and C.J. Jenkins were charged with ten indictments, and a fine of $500 in each case was imposed. The men paid the fines, and they were released from prison. The entire amount paid was $2,200. The prosecuting attorney got $1,500, the clerk got $500 and the sheriff got $200.[64] In May 1886, the jury decided that the Turf Exchange had the right to sell pools.[65] In 1896, every gambling house in Louisville closed its doors. Louisville mayor Henry S. Tyler issued the order to close the gambling houses.[66] In the 1920s, Prohibition brought an end to alcohol sales, and with the end of saloons came the end to gambling. In 1910, the Churchmen's Federation led the way in the progressive movement in combating immorality in the city. The Churchman's Federation led the Kentucky Anti-Racetrack Gambling Commission and in 1923 became the platform for the Democratic Party. When the commission received the endorsement of the Ku Klux Klan, the cause lost support. In 1927, the progressive anti-gambling movement came to an end, when a Republican, Flem Sampson, won the popular vote.

Gambling Makes a Comeback: 1930–2022

In 1891, lotteries came to an end due to a series of scandals, but in 1930 the Kentucky state legislature allowed "bank night lotteries" at movie theaters. In 1941, the bank lotteries came to an end. In 1908, bookmakers were outlawed from Churchill Downs.

In the 1950s, the Kentucky state legislature allowed bingos at churches and other nonprofit organizations to raise money and exempted them from anti-gambling laws. In 1988, lotteries returned as a state-run operation to raise money for education. On April 4, 1989, Louisville residents participated in the first legally sanctioned lottery sale.[67] In March 2013, the Kentucky Lottery board approved keno, and Kentucky residents were given the option to play the game. The game had drawings every five minutes almost around the clock. The game was expected to bring Kentucky $14.5 million a year. Of the 2,800 lottery outlets in Kentucky, about 200 agreed to offer the casino-style game. And about 200 new outlets signed on to offer only keno, including about 70 bars, restaurants, legion posts and other locations in Jefferson County. Kentucky became the fifteenth state to offer keno, including Missouri, Ohio and West Virginia.[68]

In 2018, Churchill Downs Incorporated opened Derby City Gaming. The business is located near the Old Louisville Downs racetrack and consists of hundreds of historical horse racing machines, which look and operate much like slot machines. The machines take in money like slot machines. In recent years, the money raised from the Derby City Gaming, along with the revenues from the five other historical horse racing venues, such as Red Mile in Lexington, Kentucky, has provided the state's horse industry additional income and helped increase purse sizes, attracting bigger fields, and allowed Kentucky to compete with Florida, California and New York for the world's fastest horses.[69] HHR machines operate with one key difference from a regular slot machine. Rather than rely on an algorithm to randomize the results of the reels, they use a previously run horse race to determine spin results. The wagering is also pari-mutuel, meaning bets are pooled and then divided among the winners. This type of wagering is legal in Kentucky. HHR machines at Derby City Gaming, with names such as "Dollar Chief" and "Fort Knox," do have one feature that would look out of place on a slot machine: a button that says "Race info." Pressing the button brings up a screen showing the date and location of the previously run races that will determine the results. Bettors can choose the order they believe the horses finished the race, but the machines discourage it, suggesting that letting it

pick for you will be much faster. The results are then animated like a slot machine. There are currently just over 3,700 HHR machines at six different sites in Kentucky. In 2020, more than $2.2 billion was bet through HHR machines. As of 2021, HHR brought in nearly $189 million and added to the tracks' operating income. The rapid growth of HHR had a legal challenge in September 2020, when the Kentucky Supreme Court ruled that the machines do not constitute pari-mutuel wagering, making them unconstitutional in the state. In February 2021, the Kentucky General Assembly stepped in and passed legislation ensuring their legality. In fiscal year 2020, the state's general fund received $15 million from the industry's $189 million commission on HHR.[70] As the saying goes, what is old is new again. Gambling has made a return to the state with lotteries, bingos, keno and slot machines in the form of pool selling, and now the debate continues over legalized casinos in Kentucky, since local Louisville residents can cross over the river into Indiana and play at Caesar's Casino in Elizabeth and Belterra Casino Resort in Florence.

EDWARD HUGHES

FIRE CHIEF, GAMBLER,
OWNER OF THE TURF EXCHANGE

Edward Hughes was born on February 1, 1828, on the southeast corner of Seventh and Green (now Liberty) Streets in Louisville, Kentucky. His father was Edward Hughes, a native of Ireland, who immigrated to America when he was a young man. He was one of six brothers: Patrick, Frank, James, John and Barney. When he was a young boy, Edward received his education at the public schools, and when he was old enough, he was employed by Glover & Company's machine shop at Ninth and Main Streets, where he learned the trade as a machinist. While working as a machinist, he joined the volunteer fire department. At that time, Louisville did not have a paid fire department or steam-powered fire engines, and the volunteers had no machines or appliances used to fight fires. They had only a small engine pumped by hand and a short section of hose. The fire company was composed of the young men of Louisville, who were drawn by the pure excitement of putting out fires. The young men joined an organization where they risked their lives for no pay. The early fire department was more like a social organization, and the scions from Louisville's best families joined the firemen brigades.[71]

At the age of nineteen, Edward became a member of Atwood Company No. 1. In 1857, the Louisville Board of Underwriters heard of a steam fire engine called the Latta manufactured in Cincinnati that proved to be successful. Louisville had previously tried two steam fire engines unsuccessfully, so the Louisville Underwriters bought the Latta. In 1858, the board offered the steam fire engine to the city of Louisville on the

condition that a paid fire department would be implemented. The offer was accepted, and in that same year, the Louisville Fire Department came into existence. The first firehouse was on the corner of Sixth Street and Congress Alley. Edward Hughes was a member of the Eclipse Company No. 1 and became a reel driver and pipeman. He made $400 a year. During that same year, Hughes was made captain of the company and later engineer, with his salary raised to $70 a month. For fourteen years, he was an engineer, but then he was promoted to assistant chief. During the mayor's race in 1878, between Charles Jacob and John Baxter,

Edward Hughes. *From* Fire & Water, *vol. 28, 1900.*

Hughes supported Baxter, who was defeated in the race. When Jacob became mayor, he appointed George Frantz as chief of the fire department and removed Hughes along with anyone else in the fire department who supported Baxter.[72]

On January 1, 1880, Hughes was appointed chief of the fire department, a position he held for twenty-two years. On January 1, 1903, he finally retired. He never married, and until the Firemen's Pension Bill was passed, he felt that firemen should not marry because he believed that a man whose life was in constant danger should not take the responsibility of leaving a wife and children without due provisions for their comfort after his death.

As a fireman, he was ranked as one of the foremost in the country. In the twenty-two years he served as a chief, he missed the National Association of Fire Chiefs convention only twice. Several times he was honored by the association electing him to office as vice president.

From his boyhood, the ringing of the bells was an irresistible command to rush to the flames and into the thickest of the fight. Even after his retirement after fifty years of service, he could not throw off the lure of the firefight. After Hughes retired and Major Tyson took over as chief, Hughes came to the assistance of a fire that broke out at the Bradas & Gheens candy factory on Bullitt Street. "Fatal 48" rang for the fire, and when the usual crowd of spectators arrived on the scene, they found Hughes, dripping with water and standing in mud up to his ankles, shouting orders as if he had never thought of leaving the service. The "Fatal 48" was a fire call box located on Sixth and Main Streets with the number 48. A superstition surrounded the firehouses that when the number 48 box was sounded, the specter of death stalked the

fire. Hundreds of thousands of dollars were lost in fires, such as Bray and Landrum's Jeans Clothing Manufactory, the fatal Bamberger-Bloom fire, the Stucky, Brent & Co. and J.H. Quast & Co. fires. Eddie Mitchell, who was four years old, was killed by gutter that came off a roof at Sixth and Main Street. When Tyson arrived, Hughes shouted: "Here, Fill, you go around on Fourth Street. I'm looking after things over here." The new chief of the fire department obeyed now private citizen Hughes's commands.

As a fire chief, Hughes was always thoughtful of his men. He called them "my boys," and during his career he asked for hundreds of favors and improvements that would benefit the men under his command. When in need of money, the men could always count on Hughes to lend them funds, and when the men were in trouble, he was the first to lend a helping hand.

Hughes was a huge lover of sports and always watched Pete Browning on the Louisville baseball team go against the St. Louis Browns. He was friends with John L. Sullivan, the Louisville prizefighter. Hughes was seated in the corner of the boxing ring, holding Sullivan's water bottle and advising him during the fight. During the Sullivan-Kilrain bout in Richburg, Mississippi, the match went for seventy-six rounds. Hughes was beside the ropes when the county sheriff stopped the fight. Hughes turned to the sheriff and said, "In the name of the governor of Mississippi, I forbid you to interfere with this fight." The sheriff thought that Hughes was the adjutant general because Hughes was wearing his fire chief uniform with gold epaulets, and the lawman immediately left. Hughes laughed and said he was glad that the sheriff did not ask him who the governor of Mississippi was because Hughes had no clue.[73]

Hughes was also a gambler. He had interests in several gambling houses, and his partners were Eli Marks and Anderson Waddell. He also bought a small string of racehorses and booked them at different racetracks, but he retired from the tracks. His favorite game of chance was faro, and he was credited as being one of the best faro players in the country and won large sums of money. He worked out a system for beating the game and never revealed his method until he gave up playing. At one time he was worth $20,000 (equivalent to $573,000 today). One night his luck ran out and his system failed, and he owed thousands of dollars. Hughes walked out of the gambling house penniless.[74] Later he regained his wealth and was part owner of the Turf Exchange.

He managed to amass a large fortune and used his money toward charity work. Every Christmas, he would buy turkeys for all the orphanages. The only way anyone knew that Hughes was responsible for the purchase of the

turkeys was because of the fact that the turkeys had to be delivered on coal wagons, which were supplied by different fire engine houses. In the floods of 1882, "The Point" was inundated, and residents were forced out of their homes. Major Hughes appeared at the lifesaving station and got John Tully to row him to the scene. He watched as houses floated downstream. As soon as he returned to shore, he gave an order for a wagon load of provisions for the sufferers and sent the fire wagons to the Point with the supplies. One wagon load was not enough for Hughes, and he sent for another wagon. When he found a mother and three babies who had lost their home during the flood, he made sure they had somewhere to live. They remained in a house that was as many times as handsome as the one they had just left. The people who were helped by Hughes had no clue that he was responsible for the assistance.

On July 19, 1903, Major Hughes was struck and killed by a trolley car on the Louisville and Eastern Railway. The accident occurred at Beechwood, a station five miles from the city limits, a few minutes after Hughes had stepped from another trolley car to visit the Eight Mile station on the Shelbyville pike. The trolley car that struck him was an express car, which left the city noon and was running about four minutes behind the car on which Hughes was a passenger. The speed of the express car was about fifteen miles an hour, and when the car hit Hughes, the force of the collision was so intense that his body was hurled high in the air. He fell on the track a few feet in front of the express car and was run over by the trucks before the car could be brought to a complete stop.

When the horrified motorman and conductor rushed to Hughes's assistance, they found his body beneath the wheels and had to move the car ahead several feet before the body could be released. When his body was taken out and laid on the grass beside the tracks, he had been dead for several minutes. His death was instantaneous. Hughes always had a premonition that he would be killed by a railcar and carried in his pocket an accident policy.

His body was taken by the express car that hit him to the undertakers of Boden Brothers on Second Street and prepared for burial. Porter Mason, the motorman of the car, and W.W. Sparrow, the conductor, were placed under arrest and charged with manslaughter. They were later released when the vice president and general manager of the railway company promised that the men would appear in court.

Edward Hughes's funeral was held at the headquarters of the fire department on Jefferson Street, between Sixth and Seventh Streets, and

Close-up of Edward Hughes Tombstone showing a bronze fireman's helmet and bugle, Cave Hill Cemetery, Louisville, Kentucky. *Author photo.*

Edward Hughes tombstone, Cave Hill Cemetery, Louisville, Kentucky. *Author photo.*

later his body was taken to Christ Church Cathedral. The body lay in state at the headquarters, and the Elks and Red Men took part in the funeral. He was laid to rest at Cave Hill Cemetery Section 14, Lot 206, Grave 1.

On July 24, 1903, the coroner's jury found that Major Hughes came to his death "by being run over by a Louisville, Anchorage, and Pee Wee Valley Railroad Company's car at Beechwood. We further find that said death was caused by an unavoidable accident and exonerate the train crew from all blame."[75]

His estate was worth $75,000, which is equivalent to $2,140,115 today. He left most of his money to his nephew Francis Bernard Hughes. He also left money for a monument—to cost no less than $1,500—at his grave site.[76]

STEVEN HOLCOMBE

INFAMOUS GAMBLER
TURNED MISSIONARY PREACHER

Steve Holcombe was born in 1835. His parents came to Louisville from Central Kentucky and settled in Shippingport. Before the Portland Canal was built, steamboats had to transfer their cargo to avoid the Falls of the Ohio. From 1828 to 1830, when the canal was being built, hundreds of workers resided in Portland. When the canal was completed in 1830, the suburb of Louisville lost its value as a transfer location, and most of the better classes of residents moved to the city. Those who could not afford to move to the city were left in the financially depressed area. Many of the workmen on the canal stayed in the suburb with no work, and the rivermen faced destitute conditions. Shippingport became a part of the city known for gambling and crime. Steve Holcombe's father died of exposure and desperation. Steve associated himself with other boys of his own age, which led him down a path of misbehavior. At the age of seven, he was a gambler. He supplied cakes, pies and fruits his mother made to sell to steamboat passengers, who waited at the canal locks as the steamboat passed through, and instead of taking the money home, he lost it at gambling.[77]

At the age of eight, he was playing cards in saloons with men. Two years later, he was addicted to gambling and spent hours at the Falls on the Ohio on a skiff looking for artifacts lost in wrecks that he might sell to fuel his gambling addiction. He was given the nickname of "The Little White Haired Pirate." In 1842, the canal was annexed by Louisville and a

Reverend Steve Holcombe. *Gross Alexander, "Steve P. Holcombe: The Converted Gambler His Life and Work,"* Louisville (KY) Courier-Journal, *1891.*

school was opened, and Steven's mother sent him to school. After three months of school, he quit. While in school, he met Mary Evans, a fellow classmate. Her parents moved to Shippingport. One of their restrictions was that she was never to see Steven Holcombe. Years later, she became his wife.[78]

At the age of eleven, Holcombe ran away from home and worked on a steamboat on the Tennessee River, and his first trip was to Florence, Alabama. He worked in the kitchen, slept on the deck and ate with the poorer laborers. He learned to defend himself. Before he was fourteen, he had already made several river trips. He began working in the upper Mississippi River trade to and from St. Louis. On the steamboats, gambling was held in the first cabins and the deckhands' quarters. His fascination for gambling grew. His mother tried to get him off the river trade and secured him a position in a physician's office, and a revivalist tried to reform the young man.[79]

Returning home from a Sunday excursion on the riverboats, Holcombe and two other boys went to the aid of a man who was crying for help. Upon offering help, they found out that the man was not badly in need of assistance and began to abuse the hoaxer and attacked him. They kicked him and left him unconscious. Holcombe returned the next day only to find the coroner holding an inquest into the assaulted man's death. The jury's verdict was death from exposure. Holcombe boarded a ship for St. Louis to escape a murder charge. While on the steamboat, he attacked a deckhand with a meat cleaver, which split his opponent's head. A little later on a trip to Omaha and St. Louis, he attacked a steward with an icepick and was put ashore. He landed in a little village on the Missouri River called Kansas City. Holcombe saw new forms of gambling and new vices. He traveled from St. Louis to New Orleans and continued on to Galveston, Texas, but he had no money and returned home. His love for Mary Evans brought him back, and he married her at his grandmother's house. But

Holcombe's love for his wife could not keep him home, and he returned to his life as a river gambler.[80]

Shortly before the Civil War, he formed a partnership with his half brother William Sanders. Holcombe used his money from New Orleans to fund his business in fish and oysters. The business was not successful and closed. After the failure of his business, Holcombe traveled to Nashville along with his wife and their first child. Holcombe and his wife grew distant, especially after the birth of their second child. During the day, he made money in a produce market, and at night he gambled. During the Civil War, supply routes between Louisville and Nashville were severed, and his produce business failed. For short time, he served with the Confederate troops, but he preferred to gamble and deserted.[81]

During the war, Holcombe was in Bowling Green, Kentucky, and became the owner of a restaurant and grocery store. He sold the business to the Confederate government for a claim and later collected a large sum of money. While in Nashville, he became seriously ill, and his wife nursed him through his illness. He began to play faro and lost all his money. Playing faro brought Holcombe back to Louisville. A young man was alleged to have betrayed Holcombe's half sister with the proposal of marriage. Holcombe was afraid of his temper and asked his two brothers to demand that the fiancé marry his sister, but the brothers refused. Holcombe went himself carrying a pistol. He met the young man near the canal in Shippingport. They began to discuss the matter and ended with the alleged betrayer's refusal to marry. He said, "We are as good as married now." Holcombe fatally shot the betrayer and held the young man in his arms until a physician arrived. He was arrested for murder but acquitted after a court trial.[82]

Holcombe returned to his life as a gambler in Nashville as a faro dealer, but he came back to Louisville and operated a gambling house for poor workingmen. In 1869, he traveled to Augusta, Georgia, and won large sums of money. He was drunk, and his temper grew worse. Frequently, he would go into a rage and smash furniture and throw food on the floor. He cursed and abused his wife by yelling at her one moment and then would treat her with kindness the next.[83]

While traveling to the horse races in Atlanta, Nashville, Key West and Havana, he practiced new tricks with cards. In New Orleans, Texas, Shreveport and other cities, he continued to gamble. In Shreveport, a gambler by the name of Buchannan whom Holcombe met at the Nashville races began to abuse Holcombe in a saloon, and the fight continued into the street. Holcombe pulled out a derringer, and Buchannan came at him with a

knife and a heavy club. When Buchannan was only ten feet away, Holcombe shouted, "I don't want to kill you," but Buchannan continued to advance and Holcombe pulled the trigger, aiming at Buchannan's heart. His pistol did not fire, so he went into a hotel, borrowed a working pistol and returned to find Buchannan. He found Buchannan and extended his hand in friendship. The quarrel ended without bloodshed, and they became friends.[84]

At Beaufort, South Carolina, Holcombe got into a saloon fight with a man who was much bigger than himself, so he drew a pistol and advanced toward his foe but was stopped. A fierce fight took place, and Holcombe won, although he had to flee town to avoid killing the other man.[85]

In 1877, he returned to Louisville. His son William was twelve years old and had seen his father drunk many times; the boy grew to dislike his father's drinking. He asked his parents to go with him to the Broadway Baptist Church to see him baptized. As they left for the church, Holcombe said to his wife, "I shall never play another game of cards." A friend overheard him and said, "Steve, you had better study." Holcombe responded, "No, I have made up my mind. I wish you would

Gamblers wore a derringer or knife or both in Louisville. One of the most popular derringers was the Remington Model 95 Double Derringer (aka "Over & Under Derringer"). The Model 95 was probably one of the most recognized and famous firearms in the world and most identified with the American West. The Model 95 was designed by William Elliot of Remington, who had previously designed a whole series of popular and successful pocket pistols and derringers for the firm. The Model 95 was unique in that the gun provided the "big bore" of the .41 rimfire cartridge in a compact package and offered the user two shots without a reload. The Model 95 remained in production from 1866 to 1935, and more than 150,000 of the pistols were produced during the sixty-nine-year run. *Author photo; special thanks to John and Sylvia Hensley at Chaplin River Antiques in Perryville, Kentucky, for allowing the author to photograph their derringer.*

tell the boys that they may count me out. They may stop my interest in the banks. I am done." His wife, who was leaning on his arm, could no longer restrain her emotions. She laughed and cried for joy.[86]

Holcombe left gambling and went into the produce business. All of his money was invested in real estate in the Portland area of Louisville. In October 1877, a stranger wanted to rent one of his houses. The man asked for a low-rent house, stating he had very little income. Holcombe told the stranger, "I am rather pressed for money myself, but maybe we can make a trade. What's your business?" The stranger replied that he was a Methodist

minister assigned to the Portland church and that he did not receive much of a salary. Holcombe told the preacher, "Well that settles it then, sir. I have been a notorious gambler, and of course, you would not want to live in a house of mine." The minister laid his hand on Holcombe's shoulder and said, "Oh, no, my brother; I do not object to living in your house." Holcombe promised to attend services the next Sunday. He kept his word and attended church after twenty-three years. Holcombe was accepted into the church. The minister's name was Dr. Gross Alexander, and he became Holcombe's best friend.[87]

When Holcombe converted to Christianity, the gambling community could not believe his conversion and wondered how long it would last before he went back to his old vices. His business suffered, and he was forced to sell all of his properties. Friends and relatives failed to help him out in his financial need, and many thought that Holcombe was hypocritical in his conversion and believed there was a sinister motive behind his actions. Failure after failure forced him to leave Louisville, and many of his acquaintances thought he was going to move to the far West and return to gambling. He worked as a hotel waiter for twenty-five dollars a month. He went on a prospecting venture in the Rocky Mountains. While on his trip, he read the Scriptures.[88]

When he returned to Louisville, Holcombe's wife sewed to support the family. Holcombe obtained a job in the fire department through his friend Captain Edward Hughes. He was assigned to the Portland engine house and worked there for two years. Four years after his conversion, his career became the topic of a Methodist ministers' meeting, and Dr. James Morris, pastor of the Walnut Street Methodist Church, visited Holcombe at the firehouse and informed him that the official board of his church had authorized him to aid in the establishment of a mission in the central part of the city and asked Holcombe to become the superintendent.[89]

The new mission was located in a vacant store on Jefferson Street, between Third and Fourth Streets. Both Dr. Morris and Holcombe held noon meetings at the new mission. Ironically, just two blocks away were faro houses Holcombe once owned and operated. Every day, Holcombe would preach at noon. People rushed in to hear him preach. The board of managers—composed of John Wheat, James Carter. P.H. Tapp, C.P. Atmore and George Wicks—chose Holcombe's next mission at a former gambling house on 436 West Jefferson. Singers from the Walnut Street church volunteered their services; plus hymnbooks and an organ were given to the church. Services were held nightly. Through his preaching, he saved drunkards, gamblers, pickpockets, burglars and tramps. An industrial school

for girls was organized through donations, including $500 from gamblers. The institution was known as the Gospel Mission. By 1886, Holcombe had changed the name to the Union Gospel Mission. Presbyterian, Episcopalian, Christian and Lutheran church members were added alongside Methodist directors on the board. His congregation grew to the point where he had to purchase a building on Jefferson Street, above First Street. The building was known as the old Smith mansion.[90]

In 1887, three men assaulted Holcombe in his mission, and during the struggle, his leg was fractured. He was confined to a bed for several weeks. All classes of people visited him at his home and thousands of letters were delivered to his house. Due to ill health, he was forced to retire. He suffered two strokes. His wife died soon after the family moved into their mission home.[91]

On February 25, 1916, Holcombe died at the Union Gospel Mission at 124 West Jefferson Street. His last statement was, "How good is it to be back at the old mission. I am ready to die." He had suffered from neck cancer. He was taken from his home in Elizabethtown, Kentucky, on February 9, 1916, to Norton Memorial Infirmary, where he was operated on. On February 17, he was taken to the city hospital after he became delirious and was treated by a nerve specialist. His condition grew worse, and he pleaded with his doctors to let him spend his last days in his mission. His daughter Mamie Holcombe was at his bedside when he passed away. Carrie Cox, his other daughter, was notified of his condition but was unable to leave her house in Elizabethtown due to one of her children being sick. His obituary in the newspaper stated that Holcombe "was one of the few men who quit the life of a gambler to enter upon the career of a missionary. For a period of thirty years he exerted an unrivaled influence for good in Louisville after he led the life of a gambler for many years previous to his conversion."[92]

After Holcombe's death, his ministry became known as Union Gospel Mission and continued ministering to "poor wayfaring strangers," welcoming them with open arms but not enabling them to remain idle. Churches came together underneath the banner of the Gospel to see that his ministry continued in their mission to never ostracize anyone and all were welcome to worship. In 1964, Union Gospel Mission became Jefferson Street Baptist Chapel.

4

Joseph Burt

Auction Pools

Joseph Burt was born on December 8, 1843, in Nashville, Tennessee. He was the son of William T. Burt and Martha Burt. His father was a private in Company F, 34th Tennessee Infantry (4th Confederate Regiment Tennessee Infantry), and fought in many major battles in the Confederate Army of the Tennessee from Murfreesboro, Tennessee, to Atlanta, Georgia. Joseph spent his youth in Nashville and received his education in Nashville. When he was a young man, he worked for Macy & Brown, hardware dealers in Nashville. In 1879, he quit the firm and moved to Louisville to accept a position with Watts, Hughes and Cathcart, turf operators. He became one of the most prominent men on the American turf. Burt and his business partner, Bob Cathcart, were two of the most efficient sellers of the auction pools. Burt's fame spread from Tennessee to Saratoga and Monmouth Park. After the system of bookmaking took the place of auction pools as a mode of wagering on the American turf, Burt associated himself with Anderson Waddell in the Newmarket poolroom on Third Avenue between Market and Main Streets. The Newmarket poolroom became known as one of the best-conducted business for placing commissions on horse races in America. The pools he sold amounted into the millions.

After the death of Waddell, Burt sold his interest in the business. In 1893, Newmarket was sold to new owners. Burt turned his attention to the brokerage business, organized the firm of Burt & Company and ran his business on Main Street, near Fourth Street. Several years later, Amos G.

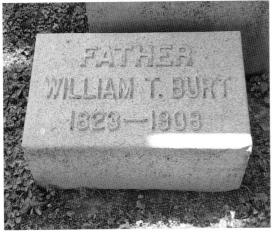

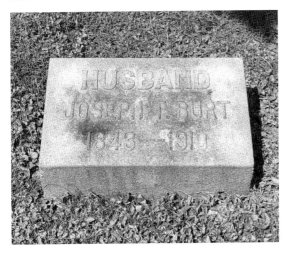

Top: Burt plot, Cave Hill Cemetery, Louisville, Kentucky. *Author photo.*

Middle: Gravestone of William T. Burt, father of Joseph Burt, Cave Hill Cemetery. *Author photo.*

Left: Joseph Burt's gravestone, Cave Hill Cemetery. *Author photo.*

McCampbell became a member of the firm, and later the firm became Burt & Campbell. Burt ran the business until his health forced him to retire.

Burt was more familiar with Thoroughbred pedigrees and knew every lineage descent of every Thoroughbred in America and England. After quitting the turf business, Burt kept a perfect line on the breeding of Thoroughbreds and could easily name the lineage of any foal. He was a contemporary of Edward Hughes, James Dick Watts, Emile Bourlier, Anderson Waddell and others.

In 1890, Joseph Burt married Anna Wasmer of Louisville. Burt's mother requested that the wedding be held at the Burt homestead in Nashville. On July 12, 1910, Burt died at his home on Floyd Street in Louisville, Kentucky, and was buried at Cave Hill Cemetery. His pallbearers were Walter Stone, Benjamin Watts, Theodore Waters, Samuel Ballard, Pinkney Varble and W.C. Williams. He was a member of the Benevolent and Protective Order of the Elks.

ELI MARKS

GAMBLER AND PART OWNER
OF THE CROCKFORD

E li Marks was born in 1842 in Metz, France, and when he was ten years old, his parents immigrated to America. His family settled in Louisville, Kentucky. Marks attended the public schools, but when he was nineteen years old, he joined the Confederate army. On June 1, 1861, he enlisted as a second sergeant of Company G, 1st Kentucky Infantry, in Owensboro, under Captain J.P. Thompson. When the 1st Kentucky was mustered out of service, Marks enlisted as a private in the 2nd Kentucky Cavalry, under General Morgan's command. On January 4, 1862, he was promoted to lieutenant. On December 26, 1862, General John Hunt Morgan appointed Marks captain and assistant quartermaster of the 2nd Kentucky Cavalry. Major Thomas Webber, commander of the 2nd Kentucky Cavalry, of General Basil Duke's brigade, under Morgan's brigade, wrote that Marks was a "faithful, sober, zealous, energetic, and honest officer."[93]

When the Civil War ended, Marks returned to Louisville and went into the grocery business. While in the army, he enjoyed gambling. Captain Castle, who had also been in Confederate general John Hunt Morgan's command, secured a location on 102 Fifth Street. Marks and Castle opened a gambling house, which eventually became one of the most famous in the South. Later, Frank McNeil and Anderson Waddell also took an interest in the business. Marks also had a financial interest in No. 69, located on Third Street. In 1883, Marks, Colonel James "Dick" Watts and Anderson Waddell established the Crockford, which was the "most spectacular of all the gambling houses in Louisville."[94] During the fourth meeting of Louisville

Jockey Club, Marks and Jack Haverly had their famous gambling duel. Christopher or J.H. "Jack" Haverly was an American theater manager and promoter of blackface minstrel shows. During the 1870s and 1880s, he built an entertainment empire on minstrel shows promoting his Haverly's Colored Minstrels and United Mastodon Minstrels. During the famous gambling duel, Marks and Haverly played faro. Marks was the dealer, and Haverly lost $30,000 ($791,750 today) he had won playing the horse races.[95]

In 1877, Marks left for Chicago and played against famous gamblers such as Mike McDonald and "Blind" John Condon. John Condon was a major part of organized gambling in Chicago in the late 1800s and into the early 1900s. He was one of the primary owners of the Garfield Park racetrack in Chicago and was also the first person to bring organized gambling into northwest Indiana when in 1892 he established the first horse racing track in the Roby section of Hammond. Mike McDonald was a crime boss, political player and businessman. In 1867, he established his first gambling establishment in Chicago, and by the mid-1880s, he was a multimillionaire. In 1873, he opened The Store, which was a gaming parlor located at the northwest corner of the intersection of North Clark and West Monroe Streets. The games were rigged, but the gambling establishment became a major attraction in the city. The Store offered not only gambling but also a saloon, hotel and fine dining room. McDonald hired Marks at The Store, and he was a dealer in faro for about a year. While he was working at the gambling house, a man entered and lost a few thousand dollars, quit playing and added a comment that the game could not be beaten. Marks was standing near the man and heard his comment, and he replied, "I'll show you." Marks had only $100 in his pocket, and three hours later, he won $20,000 ($573,000). Condon and Marks traveled east, and for several years, Marks was a successful gambler at the fashionable resorts in New York. At Long Branch, he won $10,000 in one night. While in New York, he met Pat Sheedy, and they became friends. During two sessions of the New York legislature, Marks operated a game for a season at Saratoga.[96] He loved horse races and won and lost large sums of money at the races.[97] Interestingly, Marks never played dice games. He also never permitted a man to play against his game when he knew the man could not afford to take the chance of depriving his family of the money.[98]

Marks returned to Louisville, and when the gambling houses were closed in 1885 under Mayor P. Booker Reed, he returned to Chicago. He came back to Louisville when gambling returned to the city and opened the Pickwick sporting resort on Fourth Street, near Market. He lost heavily, and ill health

forced him to retire from gambling. The last time he visited Louisville was just after faro had been closed and poker was allowed to be played. He played a freeze out game with Jim Crawford and lost. The gambling house was located on No. 206 Race Street.[99] Marks retired to a farm near the city. He suffered from heart trouble and complications from his liver and kidneys. His wife nursed him during his illness. His fondness for a good dinner with his friends was an indirect cause of his death. All his fortunes were gone, but his friends took care of him for two years.

Eli Marks died on February 19, 1895. His body was taken to the home of his sister Mrs. T. Metzger at 722 First Street, where his funeral took place. Rabbi Moses conducted the services, and Marks was laid to rest at Adas Israel Cemetery. His pallbearers were General Basil Duke, General John B. Castleman, former mayors Charles Jacob and Booker Reed, Judge R.H. Thompson, Major George Eastin, Captain Sam Murrell and Emile Bourlier. The active pallbearers were General Thomas H. Taylor, Major Owens and Captain Krakel of the police force and Norvin Grey and Lum Simons. Many Confederate veterans also attended the funeral. According to an obituary, Marks had married Henrietta Ingham of St. Louis and his son Charles Marks was employed at the MacCauley Theater. Harry Marks, a son from his first marriage who lived in Chicago, was adopted by Eli and took his name.[100]

Confederate general Thomas Taylor was a good friend of Marks and admired his many qualities. Taylor said that Marks was

> in my regiment, the First Kentucky, early in the war, going out in the company of Captain Jack Thompson from Owensboro. When this regiment disbanded he joined Morgan's command and with the rank of captain served in the quartermaster's department until the close of the war. I have never known a braver or better soldier, a more reliable friend, a more truthful man, nor a more generous, liberal human being. He would give his last dollar away and was as tender-hearted as a woman.

Emile Bourlier said that Marks "literally did not know what money was for…and to that fact was largely due his success as a gambler. The man who 'pinches' can never succeed at gambling." James "Dick" Watts said, "Nobody ever saw Eli Marks do a mean thing." Other admirers said that Marks "did not know how to say 'No' when asked for a favor. If he could not do it himself he would have it done if it lay in his power."[101] Rabbi Moses concluded that Marks

was brave and manly, like a lion in battle and like a dove in peace. It has been said that he gave his last cent many a time to defray the funeral expenses of a fallen man. He loved mankind more than he ever loved himself. He loved money, but not to hoard it away, but to give it to relieve the fallen and wretched. How much humanity he had is shown by the fact that the foremost in the city are here today to do honor to his memory. Let us do him justice and tear away disguises. He was an honest man, never wrong doing anyone. Millions upon millions are made by speculators in various ways who use their money to the detriment of humanity. This man was charitable, and had that within him that made all men love him. Farewell, Eli Marks, let us cover thy life with the mantle of charity because of thy noble nature and acts of love toward humanity.[102]

Colonel John James Douglas

Prince of Sports

J ohn J. Douglas was born on December 4, 1840, in Louisville, Kentucky. He was the son of James W. Douglas, a miller, and Sarah Janes Douglas. He began his career as a teamster. When he was a teenager, he opened a "policy shop" or lottery on Jefferson Street near Third Street. The lottery shop was one of thirty-nine similar local branches of a lottery owned in New York and operated under a charter from the State of Kentucky. After five years in the lottery shop, his abilities in the business impressed the company's owners and they made him a manager for the entire state.[103]

Tickets for the monthly drawings were sold all over the country as well in Louisville and Kentucky, and Douglas handled sales on average $8,000 a day ($180,931 today). For twenty years, he continued as head of the state lottery, and during that time, he amassed a huge fortune. When the company's charter expired, John Douglas added a business partner, B.S. Stewart, in the "Frankfort Lottery," which was operated for the partial benefit of the schools for Frankfort. For ten years, he operated the lottery and increased his wealth.

In the early 1880s, the popularity of the game began to wane, and shortly afterward a federal statute was passed that prohibited the use of the mail for the lottery's exploitation. Douglas got into a legal battle to prevent the suppression of his lucrative business and personally led the battle. The legal battle in which he tried to save the lotteries brought him nationwide attention. The legal cases were carried through the local courts, the Kentucky Court of Appeals and the federal courts and finally the Supreme Court of the United States. On March 5, 1892, the governor of Kentucky signed the Goebel

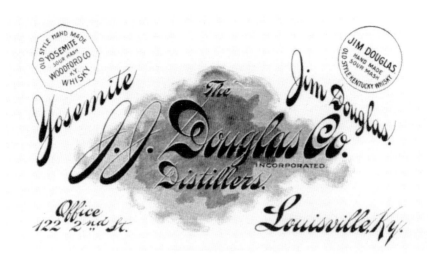

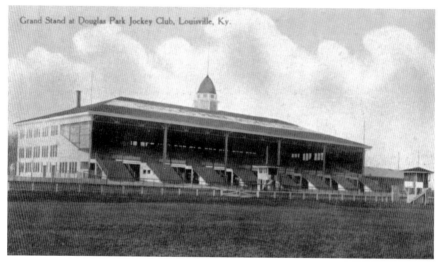

Top: The J.J. Douglas Company advertisement. *From* Wine and Spirit Bulletin *(1903)*.

Bottom: Grandstand at the Douglas Park Grandstand, Louisville, Kentucky. *Ronald Morgan Kentucky Postcard Collection, Graphic 5, 1912, Kentucky Historical Society Digital Archives.*

anti-lottery law, which made the dealing in lottery tickets a felony. Douglas accepted defeat in good spirit and publicly announced that he would not operate in violation of the law.

After giving up the lottery business, he was associated with Lum Simons and William "Bill" Bailey, who was the jailer of Jefferson County. They were engaged in a brokerage and "claim shaving" business.

Later, John Douglas became a wholesale liquor dealer and importer of liquor and formed a company called J.J. Douglas Company. He was a rectifier or blender of other company's bourbons to make Yosemite, Jim Douglas, Douglas Malt, Eagle Elk, Glynn Valley, Winetrop Club, Carlton, Salvator and Meleager. His main office was at 224 West Main Street in Louisville.

He was also a turfman and bred, owned and raced both pacers and trotting horses. In 1896, Douglas moved from Louisville to Middletown. His home was on Shelbyville Road, near Anchorage, and his home was one of the showplaces of Middletown. The home was purchased from the Finzer estate. Nicholas Finzer was in the tobacco business along with his brothers, and his widow, Agnes Finzer, sold the farm to Douglas. The farm consisted of four hundred acres. A spring on his property led the first settlers of the old town of Middletown to locate their homes on his property. Douglas always kept the spring open to the public. On his farm, he did not have a weed or stump.

He called his home Douglas Place but later renamed the stables the Eothen Stock Farm. His home was at one time was one of the most famous in the country. Douglas was not only interested in horses from an economic standpoint but loved the animals as well.

He was a successful breeder of trotters and pacers. The best-known horse that was foaled on his farm was Heno, which was sold to John E. Madden for $500. Later, the horse was valued in the thousands. McDole was the best trotter Douglas ever owned. Another famous trotter that Douglas owned was Joe Johnson.

In September 1895, to coincide with the opening of the Grand Army of the Republic Reunion in Louisville, Douglas personally founded and opened Douglas Park. He thought that trotters and pacing horses should have a premium venue and purchased property south of Louisville in the Beechmont suburbs where Southside Drive joins Second Street. He constructed a one-mile oval that featured bank turns. A large grandstand was constructed along with stables and a clubhouse. Not too long after the opening of Douglas Park, Douglas was made a colonel by the Kentucky governor.

In December 1905, through Colonel Sum Simons, Douglas disposed of all his horses, both trotters and pacers, at a dispersal sale in Lexington. The richest stake in the world was Pilatus, which sold for $1,800, which is equivalent to $51,362 today. Free Fancy brought $120, Cecil Wilkes brought $210, Eggatine brought $120, Mayne Nutwood brought $300, Tiggaliska brought $400 and Dallantus brought $200.[104] Also in

December 1905, Douglas sold Douglas Park to the Louis Cella of the Western Jockey Club. The track sold for $100,000. Colonel Simons also conducted the sale of the Douglas Racetrack. He also had an option on the Douglas Park and made the trip to St. Louis, where he met Louis Cella, and the deal was closed. According to newspaper reports, Simons received $10,000 for his holdings.

The newly formed incorporation for Douglas Park stated that the track would encourage and promote agriculture and the improvement of stock—particularly running, trotting and pacing horses—by giving exhibits or contests of speed and races between horses for premiums, purses or other rewards. The incorporation would also maintain a fairgrounds and racetrack.[105] Louis Cella had 2,490 shares in the new corporation. In 1907, Churchill Downs and Douglas Park formed a holding company, and each racetrack put $300,000 into the new company. The agreement would have a thirty-day meeting at Churchill Downs in the spring and a fall meeting at Douglas Park.[106] The track closed from 1906 to 1913. In 1913, the property was renovated, and the venue was changed to Thoroughbred racing.

Among horsemen, Douglas had friends throughout the entire United States and foreign countries. Whenever any of his horsemen friends came over to visit, he would royally entertain them. He became known as a "prince of good fellows." He was also a power in local politics. Although he never sought and refused repeatedly to accept public office, he gave his time and money in many hard-contested campaigns to aid a friend.

He also helped his friends in need. According to one story, Douglas and some of his friends went on a fishing trip to Florida. One of his friends was a leading lawyer in Louisville and was heavily involved in a local bank that was on the verge of collapsing. One day, when the group was ready to go fishing, the lawyer held back and Douglas asked him, "What's the trouble, old fellow?" The lawyer told Douglas that he was just informed that the bank had failed and everything he owned was wiped out, except his home, which he was prepared to sell once he got back to Louisville. Douglas asked him, "How much do you need to tide you over?" The lawyer told him he needed $35,000, which is the equivalent to $806,306 today. Douglas sat down, wrote a check for the entire amount, handed the check to the lawyer and said, "Now, will you go fishing?" The lawyer paid Douglas back the $35,000.

Douglas also contributed to institutions for the poor and the sick and the orphans, regardless of their religious affiliations. He annually gave away thousands of dollars to worthy cases of need brought to his personal

attention. He also helped in any way to aid in the development of Louisville, whether in a social or business sphere.

In May 1915, the J.J. Douglas Company was having financial problems, and by September 1915, a committee representing the creditors of the S.J. Greenbaum Company had met in Louisville to arrange the entire takeover of the affairs of the Greenbaum Company, the J.J. Douglas Company, the Neversink Distilling Company and the Old Pepper Distilling Company. One year later, in 1916, approximately $70,000 (equivalent to $1,707,408 in today's value) was ready to be distributed to the creditors of the J.J. Douglas Company, one of the subsidiaries of the S.J. Greenbaum Company, which went bankrupt. The assets of the J.J. Douglas Company were liquidated, and a sum equivalent to 90 percent of the claims was ready to be distributed.[107]

Douglas was twice married. His first wife was Ella Self Douglas, who died in March 1905, and afterward, he had his mother and sisters move into his home. His mother died on January 7, 1916. She was ninety-one years old. He married after his mother's death. His second wife was Nannie Francis Douglas. His four sisters were Ella and Tillie Douglas, Herminia Broadhurst and Bell Ashburn. Colonel Douglas had no children.

On January 2, 1917, Colonel James J. Douglas died in his home in Middletown from chronic intestinal nephritis. His funeral took place at his residence. He was seventy-four years old. The funeral party drove their cars from the residence to Cave Hill Cemetery, where he was buried in the family plot, Section E, Lot 30, Grave 8. The Compass Lodge of Masons was in charge of the exercises at the gravesite. His pallbearers were Dr. L.D. Mason, J. . Kavanaugh, William Duffy, Louis and Otto Seelbach, Harry W. Brennan, Walter Kohn, J.T. Moran, Angeran Gray, William Bowe, W.T. Milton, Lawrence Cox, Charles Smith, James B. Smith and Edward H. Hayes.

In February 1917, Nannie Francis Douglas sued to recover from the Douglas estate half of all the personality in her own right and one-third of the realty for life. In Douglas's will, he left her $11,000 in cash and two pieces of property. Douglas put an antenuptial contract in the will. Four sisters named in the will received $64,000. Nannie claimed she knew nothing of the antenuptial clause in the will. She was given only $26,000 out of an estimated $500,000 to $750,000, which is equivalent to $14,713,291 in 2018 money. The sisters were defendants in the lawsuit. In August 1917, a compromise was reached between Nannie Bliss Douglas and other heirs to the estate. Nannie would be paid a substantial sum of money in cash, and she agreed to relinquish all claims to any and all of the real estate.[108]

Left: John James Douglas monument, Cave Hill Cemetery, Section E, Lot 30, Grave 8. *Author photo.*

Below: John James Douglas monument, Cave Hill Cemetery, Section E, Lot 30, Grave 8. *Author photo.*

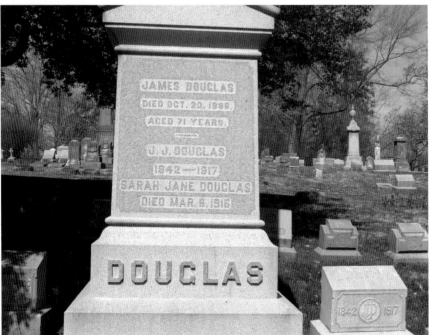

In 1918, Douglas Park was no longer a racetrack and became the exercise and training track for the Churchill Downs, used to stable Thoroughbreds that could not be accommodated at Churchill Downs. In 1939, the Douglas Park grandstand and clubhouse were demolished, and fires in the 1940s and 1950s severely damaged the horse barns. On October 26, 1952, a fire completely destroyed the largest horse barn at Douglas Park, killing sixty-eight horses. In 1954, Churchill Downs began to sell off the Douglas Park property, and by 1958, Douglas Park racecourse no longer existed. Currently, an industrial park, homes and apartments occupy the Douglas Park property. The only remnants of the Douglas Park racetrack are the brick columns leading to Holy Rosary Academy.[109] After Douglas's death in 1917, the Eothen Stock Farm or Douglas Place went through several owners, and his home was eventually demolished. In 1973, the farm developed into a residential subdivision known as Douglass Hills. The only thing left from the Douglas Place farm is a springhouse.

BOB CATHCART

POOL SELLER

B ob Cathcart was one of the best-known men on the American turf. He was born in 1841 in Baltimore, Maryland, and was educated at a prominent collegiate institute near the city. When he was twenty-one years old, he moved to New York City, where he earned the reputation of a leading sportsman. When Cathcart arrived in New York, John Morrissey, a noted politician and sportsman, was into pool selling at the races in the city. One night, the auctioneer fell sick and died, and Morrissey was in desperate need to replace him. Cathcart heard about the death of the auctioneer and begged to fill the vacant position. Morrissey thought he would try Cathcart's qualities and took him to the sporting headquarters, pointed out the stand and told him to mount the stand and told him to do his best. Within a few moments, Cathcart proved he had the ability as an auctioneer. Morrissey was thrilled with Cathcart and made him his pool seller. Morrissey and Cathcart became the best of friends and remained so until Morrissey's death. Cathcart stayed in the east for ten years and was employed by Morrissey at Saratoga, Long Branch and many other areas frequented by turfmen.[110]

In 1873, Morrissey brought Cathcart and Professor Louis G. Dromel to Louisville so they could attend the horse races and engaged in pool selling. Dromel was in charge of the mutuels on all the tracks. Cathcart became a favorite in Louisville and eventually took a position at the Hughes & Watts as a pool seller at the Turf Exchange. After a year, Cathcart purchased an interest in the firm and became a partner. He made his home in New York

and spent most of his time as an auctioneer for Reed & Spencer. His visits to Louisville were made during the spring and fall, when the races were being held. Everyone in Kentucky knew Cathcart. He ran a fair, honest and fraud-free business. He treated all men alike. He would not allow experienced turfmen to take advantage of young and unsophisticated men.[111]

Cathcart was always dressed in the height of fashion and lavishly spent his money. He always had a black mustache. He was polite, generous and friendly with everybody he met. Much of his money went to charity, and he made sure that none of his friends were in distress and frequently helped strangers in want. He never forgot a name or face. He was a scholar, conversationalist and philosopher. He studied to become a minister at one time. At the time of his death, he was known to turfmen around the world. His health began to fail, and he traveled to Hot Springs, Arkansas, to help recover from his "apoplectic" attacks. He received no benefits from Arkansas, so he returned to Louisville and applied himself to his business. He traveled to Cincinnati with Fred Bishop, his financial agent, and took charge of the pooling privileges of the Latonia racetrack. When he left the city, he remarked he was not feeling well and died on October 7, 1885. He was married but had no children. His wife lived in New York, and his parents lived in Baltimore. His brother John Cathcart, who was in charge of the French mutuals at the Turf Exchange, lived in Louisville.[112]

Major Ed Hughes, Joe Burt and his brother John took the Mobile and Ohio Railroad to Cincinnati to accompany Cathcart's body back to Baltimore.[113]

JAMES CORNELL

FIRST PERSON TO INTRODUCE KENO IN KENTUCKY

Cornell was born on April 19, 1842, in Virginia but was raised in Louisville, Kentucky, and became known as one of the foremost sporting men in Kentucky. In 1860, Cornell bought a building on the northeast corner of Fourth and Green (now Liberty) Streets opposite the old Louisville Opera house and opened the Pearl saloon. The Pearl became the resort of some of the best-known men in Louisville, and Cornell made friends quickly. His saloon became known for the finest brands of whiskey and cigars.[114]

When the Civil War broke out, the Pearl became the favorite resort of Union officers, and Cornell's business became so popular he had to take on a partner. His business partner was James "Dick" Watts. At the time of the Civil War, keno was first introduced in other cities and in the army. Cornell decided to open a keno gambling house. The Pearl became the first keno house in Kentucky; the cards were pegged at a dollar a piece, and the game became immensely popular.[115]

In 1867, after the Civil War, James Cornell went into business with Len Rogers, and the name of the business changed to Cornell & Rogers and the Pearl saloon. During Christmas 1867, Cornell supplied "as good an article of egg nog as ever was made in Louisville."[116] His business was a success, but the money he made did not last him long because his generosity went far beyond his means. He was always ready to divide his last cent with a friend. In 1876, he entered politics and became a candidate for marshal of the City Court. Cornell had no money, so his friends came to his rescue and

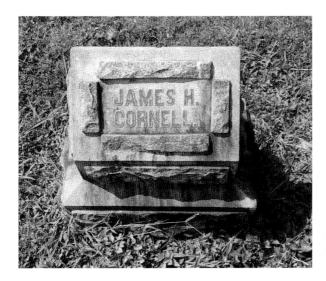

Tombstone of James Cornell, Cave Hill Cemetery, Louisville, Kentucky. *Author photo.*

advanced him the money for his campaign. He won the election. He kept a close account of the money and paid back every dollar his friends advanced him and taken from his office.[117]

Not too long after Cornell accepted the office of marshal, Prosecuting Attorney Boland ruled against Cornell and a settlement was made between both parties. The rule was issued by the city against Cornell to force him to make a report to the city of the financial condition of his office for three months as required by law, in response to the rule, which said the city was indebted to Cornell for one month and for the other two months he was indebted to the city. Cornell asked that nothing be done until the finance committee of the council examined his books as proposed. The court decided to make no ruling until his committee did as contemplated. The trouble was caused by nothing else than Marshal Cornell's failure to keep his books in proper order.[118] When his term of office expired, he was looking for employment. His next job was as a caller with Watts & Hughes keno room, near the Crockford, and he became one of the best callers in the city. Illness took a toll, and his mind began to fail. Hour after hour he would lie in bed and call off numbers of the keno cards and ask if they had been pegged. He died on June 10, 1884, at the age of forty-two at his home on Green Street (now Liberty Street) near Eleventh Street and was laid to rest at Cave Hill Cemetery. His was married to Eveline Downes Powell Cornell. He had one son, Samuel Parker Cornell, and a daughter, Annie Cornell Lindenberger.

9

MAJOR DAVID WARD SANDERS

THE GAMBLERS' LAWYER

David Ward Sanders was born on October 14, 1836, on the Richmond plantation in Franklin, Holmes County, Mississippi. His father, David Sanders, was a physician, and his mother was the daughter of Chief Justice Benjamin Dulaney. Sanders studied at Franklin, Mississippi, in a church built by his maternal grandfather. On November 20, 1846, with his sister Margaret, Sanders left Mississippi for North Carolina. He studied at the University of North Carolina, and in 1855, he graduated with honors in law. In 1852, his sister Margaret married Leland Noel. David Sanders lived in the Noel home, near Lexington, Mississippi. After graduation in 1855, he returned to Homes County, Mississippi, and studied law in the office under Walter Brooks. In 1857, he was admitted to the bar and took a law position at Brooks's law firm at Lexington, Mississippi. In 1859, at the age of twenty-two, Sanders became a member of the Mississippi legislature.[119]

He voted for a call of secession at the Secession Convention, and on January 9, 1861, Mississippi seceded from the Union. On that same day, Sanders married Anne Stephens. During the war, he served as an adjutant and major under Confederate general Samuel French. Sanders built the world's first sand fort at Fort Fisher, located at the mouth of the Cape Fear River in Virginia. He served for two years in Virginia and North Carolina, but French was transferred to the western theater. During the Georgia Campaign, Sanders covered the retreat of Confederate general Joseph Johnston's forces to Atlanta, and French's forces were the last to leave Atlanta.

Sanders also covered the retreat during General William T. Sherman's March to the Sea. At the Battle of Altoona Pass, General French, along with Sanders's guidance, managed to surround Union forces at the pass, cutting them off from Sherman's main army. Major Sanders rode out to the Union forces and proposed terms of surrender. Sanders tied a white handkerchief to the butt end of a rifle and advanced toward the Union line. Some of the Union soldiers immediately ran a white flag up a flagpole. Certain of the white flag, the Wisconsin troops tore the flag from the fastening, and from a signal station at the top of a mountain within a fortified enclosure, a signal corps waved a signal of distress thirty miles away to Sherman and the main Union army. Sherman messaged back to hold the fort, and he was on his way. Sherman arrived and forced the Confederates to retreat.[120]

After the Civil War, Sanders mustered out of service and returned to Mississippi, but he did not feel safe practicing law in his home state, so on March 28, 1868, Sanders and his wife moved to Louisville, Kentucky, and began to practice law in the river city. His first major fight was to keep the lottery companies in business. He did not care that every religious sect, except the Jewish community, in America raised money by conducting lotteries. He argued that revoking the Kentucky lottery company was to impair the right of contract. He fought with the State of Kentucky for fifteen years before his case was finally heard by the Supreme Court.[121]

The history of the lottery in Kentucky began in 1838 when the General Assembly granted a man the right to operate a lottery in order to raise $100,000 to establish a school fund for the city of Frankfort. The company became known as the Frankfort Lottery Company. Twelve years later, the assembly granted another party permission to host a lottery for an endowment fund for the Henry Academy and Female College. In each of the lottery charters, the state gave the contracting parties the right to dispose of their privileges. Each did so, and James J. Douglas secured the holdings of both companies and combined them to form the Kentucky State Lottery Company.[122]

Douglas's offices were scattered throughout Louisville and the state. Anyone who managed to guess the correct numbers won large prizes. Many played the numbers four, eleven, forty-four, which were numbers on the lottery wheel. A patron of the games could wager as little as a nickel. Public sentiment began to change, and the lottery was seen as a gambling evil. Sanders became the defender of the lottery. He continued to defend the lottery kings for fifteen years even after lotteries were made illegal. In 1891, the new Kentucky State Constitution revoked all lottery contracts,

but Sanders attacked certain clauses in the Constitution and carried the fight through every court in the state; eventually, the case was heard by the Supreme Court. In 1897, the Supreme Court and lesser courts handed down their decision, ruling that lotteries were a form a gambling and were demoralizing to the community. The court ruled that the state had the duty to protect the morals of the public and that a General Assembly could not grant a license to carry gambling. The Kentucky State Lottery was forced to close its doors.[123]

While defending the lotteries, he defeated all efforts to annul lottery contracts as granted originally by the state legislature. The lottery wheel was played twice a day at the central lottery office on Third and Green (now Liberty) Streets.[124]

Although known for his defense of the lottery, Douglas also fought and won a pioneer case in Kentucky's establishment for the rights of minority stockholders. C.P. Huntington, who was a railroad magnate, tried to control the "short route" railroad along Louisville's riverfront. Sanders was a stockholder in the company that built the trestle from Fourteenth Street to Preston Street, which connected to the Illinois Central and the Chesapeake & Ohio Railways. Huntington acquired the controlling interest and tried to force out the minority stockholders.[125]

Sanders sued Huntington and brought him into contempt of court. Huntington was barred out of Kentucky, and the short-route railroad was thrown into the hands of a receiver. Huntington gave in to Sanders and bought the holdings of the minority stockholders at high prices in order to get himself out of the middle of a bad situation. Other attorneys and minority stockholders sought Sanders's advice on similar cases.[126]

Sanders also proved the right of an electric railway to condemn property along a proposed right-of-way. Sanders was consul for Kentucky's first interurban line, which was the Louisville, Anchorage & Pee Wee Valley Railroad. Residents on the eastern end of the county fought the railroad's right-of-way. Sanders brought suit against every one of the landowners who contested the right-of-way. He won his suit, condemning their property and gaining the right for the electric company to condemn property became law.[127]

With his vast sums of money, Sanders lived in the lap of luxury. He refused to dine alone, and every dinner cost him between $3 and $1,000. On one occasion, he invited the entire Kentucky state legislature to dine with him in Louisville at the Rufer's Hotel. Jim Taylor, who was an African American chef at Rufer's, was known as one of the better chefs in Kentucky. When Sanders was handed the bill, the amount was $600. When he saw

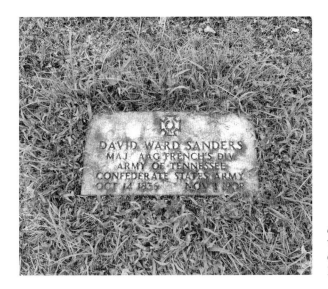

Confederate major David Ward Sanders Cave Hill Cemetery, Louisville, Kentucky. *Author photo.*

the total, Sanders remarked, "Why, that's too cheap for such a dinner as we have enjoyed." He took out ten $100 bills and said, "Divide the rest of that change among the cook and waiters." His money came from the retainers he charged the lottery company, which was $20,000 annually.[128]

Wherever Sanders went, he took his African American body servant Ben, but Sanders gave him the nickname of "Snuff." If Ben was not welcome, neither was Sanders. He took Ben along to banquets, and Sanders always gave Ben a drink. When Ben had too much to drink, Sanders would call him a cab, help Ben into the vehicle and take him home and put him to bed.[129]

Sanders was a lawyer for fifty years, and during his career, he became a legal giant. He died on November 1, 1909, at his apartment at the Galt House and was buried in Cave Hill Cemetery.

EMILE BOURLIER

PRESIDENT OF THE LOUISVILLE JOCKEY CLUB AND CHURCHILL DOWNS

Emile Bourlier was born on January 3, 1842, in Louisville, Kentucky, and attended the local schools. During the Civil War, he was a shipping clerk for the firm of John Tompkins & Company. He resigned to accept a position as a clerk at the Galt House, which was located at Second and Main Streets. For three years, he was a clerk in Cincinnati at the Burnett House. He returned to Louisville and formed a partnership with his brother Al Bourlier in a wholesale stove and tinware company. His business was successful, and he became known as one of the shrewdest and most capable businessmen in the city. When Ed Hughes was made chief of the Fire Department in 1879, Bourlier became chief clerk of the Fire Department at Mayor John Baxter's request.[130] His duties included keeping all the books and records of the office in order, ordering repairs to the firehouse if necessary and figuring the exact amount needed to maintain the department. He became known to firemen throughout the country and held the position for seventeen years.

Bourlier was a charter member of the Louisville Lodge of Elks. He was also a member of Preston, Eureka and Louisville Council and Louisville Commandery of the Masonic Lodge. While in control of the Masonic Temple Theater, he became known in the theatrical world and was friends with many of the leading actors and actresses of the American stage. He also booked attractions from New York for not only his theater but also the Grand Theater.

Bourlier was also one of the best-known turfmen in the country. He worked for the firm of Hughes, Watts & Cathcart and was known as one of the most prominent men connected with the western turf. He was also president of the Bourlier Cornice and Roofing Company. In 1886, he paid $22,500 (equivalent to $709,255 today) for the Turf Exchange. On March 30, 1886, the City of Louisville served a verbal notice to the Law and Order Club attorney John Baskin, who informed Emile Bourlier, who owned the business, that he must close his poolrooms on Third Street and discontinue selling pools on horse races. Louisville had just passed the gambling bill. Bourlier told a reporter that he would abide by the law and stop all betting, auction pools, combinations and Paris mutuels. Earlier, the Supreme Court

Emile Bourlier. *Photograph from* The History of the Louisville Lodge No. 8, B.P.O. Elks: Organized April 28, 1877, Reorganized and Incorporated January 9, 1884, *p. 1925.*

had ruled that no lottery charter could be granted. In 1880, the charters of lottery companies operating in Kentucky were repealed by the legislature, but the Kentucky Court of Appeals ruled that the charter of the Stewart Lottery was valid. The legal question was whether the Kentucky State Court of Appeals would follow the Supreme Court ruling. The Stewart Lottery was for a particular purpose, which was to raise a certain amount of money.[131]

A month later, on April 15, 1886, the Ordinance Court dismissed several minor cases dealing with poolroom cases, but Emile Bourlier, the owner of the Jockey Club Pool-Room on Third Street, was charged with keeping a disorderly house. On April 22, 1886, Bourlier closed the Jockey Club, and he decided to focus his attention on the Turf Exchange. In 1880, James "Dick" Watts & Company owned the Turf Exchange, and the enterprise was later owned by Hughes, Cathcart, & Company. Dick Watts withdrew his interest in the company, and Bob Cathcart died in Cincinnati while the races were run in Latonia. Bourlier began selling auction pools at the Turf Exchange, but no combination or "French" pools would be sold due to the new law. Frederick Bishop would continue as manager, and Joe Burt would continue to be the auctioneer.[132]

On May 14, 1886, Marshal Risley issued arrest warrants for Emile Bourlier, E.B. Banks, Daniel Downing, W. Boardman, Thomas Tucker, Henry Wehmoff, Dave Durbin, Henry Pelty, Hal Dent, Samuel Bishop and

Dave Kahn. The warrant charged that the poolrooms were opened on April 16, and the charge was for keeping a disorderly house. The arrests did not affect the pools on Derby Day. The new owners of the Law and Order Club tried to interrupt the business of poolrooms but failed in the courts. Bourlier told reporters that he ran his poolrooms in a legitimate manner.[133] On May 26, 1886, the jury convened the case of George Bissell, owner of the Turf Exchange, against Emile Bourlier, Anderson Waddell, Fred Bishop and Edward Hughes. The case was submitted on an agreed statement of facts to the effect that pools were sold at the house; that the plaintiff had given the defendants, who were tenants, written notice that they must either cease selling pools or leave the house and they refused to do either; and he notified them that they must leave and issued warrants. Pool selling was mentioned as the purpose for which the property was being leased. Attorney for the defense Kohn read the opinion of *Smith v. the Commonwealth*, which stated that after the Check case, on which most of the poolroom warrants were issued, the Warren County Fair could not be properly be indicted for allowing pool selling, because pool selling was neither a game nor a wager. The jury ruled that they did not "have the purpose of determining whether pool selling in the city of Louisville contrary to the law, nor are they to punish defendants for violations of said law." They were to determine whether or not the defendants were guilty or not guilty of a violation of the stipulations of the lease, which would forfeit the same. The jury determined that the defendants strictly conformed to the conditions and did not violate any of the stipulations. A verdict of "not guilty" was returned.[134]

In 1892, Bourlier bought the St. Leger for $6,025 ($196,183) and planned to open the business as a hotel and restaurant. In 1894, the new Louisville Jockey Club was formed with William Schulte as president and Emile Bourlier as vice president. The presiding judge was Colonel Meriwether Lewis Clark. The directors were William E. Applegate, Henry Wehmhoff, Emile Bourlier, W.F. Schulte and W.G. Osborne. Emile Bourlier and William Edward Applegate formed a syndicate to make improvements, reorganize the track and bring the track out of bankruptcy. Once the new company had been formed, work began on the improving the stables and buildings at Churchill Downs. Some of the buildings were torn down completely, and new ones were erected. The grandstand was remodeled, and a new one was built to avoid the afternoon sun.[135] In 1894, Churchill Downs had fallen on hard times. When the derby first opened, twenty thousand people attended the track, and at that time, there were only 6 racetracks in the country. By 1894, there were 138 tracks. Expenditures had risen, and the income

and revenue were smaller. Churchill Downs was owned by the Louisville Jockey Club through a lease with John Churchill, who ranked second only to Colonel Clark as the largest stockholder of the club stock. Colonel Clark and Churchill had the controlling interest of the company. In 1875, yearlings could be bought for $200, but by 1894, they sold for thousands. Colonel Clark brought together race breeders, and Clark told them that the winner of the derby would sell more than what they paid for their horses. Clark went to England and France and devoted two years to studying the turf abroad, and the Kentucky Derby, Kentucky Oaks, Clark Stakes, St. Leger and Louisville Cup were modeled after classic English events. As a result of the races and the work of the Jockey Club, a surge in the breeding of racehorses in the South and the price for yearlings rose 300 to 400 percent. For the first ten years, Colonel Clark did not draw a salary, but later, he was allotted a salary of $5,000 a year; however, he never took the money because there was no money in the treasury. He was president of the Jockey Club for twenty years. Clark told a reporter that he was no longer going to carry the heavy burden of the running Churchill Downs and the Jockey Club. Bourlier kept Clark on as presiding judge.[136]

By 1894, Bourlier continued to own the Turf Exchange and was heavily invested in the Latonia track in Covington, Kentucky. He was also a large stockholder in the Oakley track and lessee of the Masonic Theater with his brother Al. On March 4, 1896, Rachel Smallwood sued Emile Bourlier, his brother Al and Henry Wehmhoff, comprising the firm of Bourlier Brothers. Smallwood claimed the Bourlier brothers were in 1893 and 1894 engaged in selling pools on horse races, and between October 15, 1893, and December 30, 1894, her son George Smallwood lost over and above the amount of winnings $2,495 ($85,964). She asked for three times the amount at $7,485 ($258,238). The Bourlier brothers sued her for $3,407 ($117,387), which George Smallwood was alleged to have won from them. The case was settled, and an order of dismissal was entered into the courts.[137]

Bourlier lived on Twelfth Street between Main and Market. He died on November 5, 1898, and was laid to rest at Cave Hill Cemetery. His funeral was held at the Christ Church Cathedral, and thousands attended. People and carriages blocked the streets from Walnut to Green (now Liberty) Streets. The Louisville Lodge of Elks, Louisville Commandery and Preston Lodge of Masons, headed by the Louisville Military Band, attended the body from the cathedral to Cave Hill Cemetery. Detachments of the fire and police departments were also present at the church and escorted the body to Cave Hill. Members of the General Council and city and county officials were at

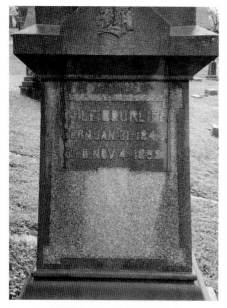

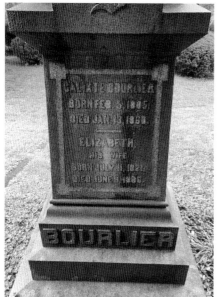

Above, left: Emile Bourlier's plot at Cave Hill Cemetery, Louisville, Kentucky. *Author photo.*

Above, right: Emile Bourlier's tombstone at Cave Hill Cemetery, Louisville, Kentucky. *Author photo.*

Left: Emile Bourlier's parents, Calixte and Elizabeth Bourlier, Cave Hill Cemetery, Louisville, Kentucky. *Author photo.*

the church. Over one thousand people attended the service at the cemetery. The funeral train was one of the longest ever seen in Louisville. Six wagons of the Fire Department draped with mourning carried the floral arrangements from the cathedral to Cave Hill.[138] In 1901, his wife, Nellie Rose Bourlier, brought a lawsuit against the new Jockey Club to force the club to issue her

certificate of 80 shares of stock. Emile Bourlier owned 160 shares of stock in the club, valued at one hundred dollars each. On January 31, 1898, the certificate was issued to Emile Bourlier, but he died intestate on November 4, 1898, leaving his wife and brother Alphonso his only heirs. After the estate was settled, Mrs. Bourlier was given 80 shares, and Al was given 80 shares. Unfortunately, Nellie Bourlier lost the certificate. The Jockey Club refused to issue the certificate for 80 shares.[139]

Colonel John "Jack" Chinn

Gambler and Owner of the
1883 Derby Winner Leonatus

John Pendleton Chinn was born in Harrodsburg, Kentucky, on February 11, 1849, and was the son of John and Elenor (Pendleton) Chinn. He was educated in the public schools of Mercer County and the University of Kentucky. He was a member of a distinguished Kentucky family dating back to pioneer days and linked by marriage to one of the historic families of Kentucky. His grandfather Christopher Chinn, who married Sarah White Stull Hardin, was a descendant of a Huguenot family whose members had to flee France after the massacre of St. Bartholomew and found refuge in Kentucky. When John Chinn was fourteen years old, he joined Confederate general John Hunt Morgan's 2nd Kentucky Cavalry as a private and remained with the raiders until Morgan was captured. Chinn once remarked that "the first horse I ever had I stole to join Morgan."[140] His brother Christopher, who was born on June 29, 1846, also joined Morgan's command. Unfortunately, in 1864, Christopher was killed at the Battle of Saltville, Virginia.

After the Civil War, in 1866, Chinn had a fight with John Dowling at the Latonia racetrack in Covington, Kentucky, in which he cut Dowling. Chinn's favorite weapon was the bowie knife. He carried the weapon in his back rear trousers pocket, but he had a way of shifting the knife to his front pocket and opening it under cover, with a blade that was seven inches long. The blade would retract like a pocketknife, but when the spring was released, it whipped open and locked into place. Chinn stated that he intended to kill Dowling, but Dowling wore a steel shirt. Chinn said: "That's what saved

him. That steel shirt. That steel made a nick in the knife." Chinn told the story that he and Dowling had some trouble about turf matters. Dowling threatened to drive Chinn off the racetrack, but Chinn was ready for him. Chinn said Dowling tried to shoot him in the back from a carriage in Chicago and drove away so fast that Chinn could not catch him. Chinn ran after Dowling half a mile down an alley. Dowling's friends came to Chinn and told him that the fight was off and that Dowling would leave Chinn alone if he left Dowling alone. Chinn said he would have killed the man if Dowling had not sent the message, but Chinn said he was glad he did not kill him. Dowling died in an asylum several years later. Chinn

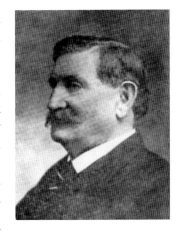

Jack Chinn. *From* The Chase: A Full Cry of Hunting, *vols. 1–2, 1920.*

once said that he would never use the knife on a gentleman: "Gentleman should never fight. They can settle their difference by a decent, gentlemanly kind of arbitration. But I would never let a scrub or a fighter back me down. I would be ashamed to go home to my wife and say that a man was looking for me, when I had this knife about me." Chinn gave his philosophy about fighting and said: "A man should fight if he is attacked by a scrub; he should fight if the honor of his home is at stake; he should fight if a woman or a weaker man are being 'put upon.' I have followed that rule always and have done a lot more fighting for other people than for myself."[141]

In 1891, in St. Louis, Illinois, according to Chinn, the racetrack officials on East Street were looking for his son Kit, who was doing the starting (to hold some horses at the post in a certain race). Chinn said he gave the officials a "piece of his mind."[142] A little later, Chinn was standing at the racetrack, engaged in conversation with an acquaintance, when a tall police officer, who had no grievance against Chinn or his acquaintance, walked up behind and took direct aim at the back of Chinn's head. Someone shouted, and Chinn turned quickly, only to receive the bullet in his mouth. The bullet came out at the back of the neck, just missing the spinal cord by a scratch. He was hurried to a hospital, fearing that the wound was mortal. In just five days, Chinn walked out of the hospital. When the police officer heard that Chinn had recovered, he promptly resigned from the force and left St. Louis, hoping never to see his would-be victim.[143] Chinn carried the bullet as a souvenir. In Nicholasville, Kentucky, a man named McCabe got into

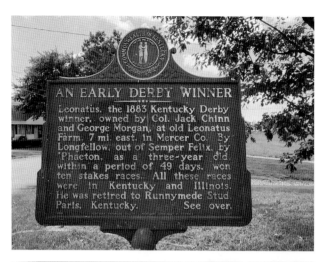

Top: Kentucky Historical Society sign titled "An Early Derby Winner," located at Youngs Park in Harrodsburg, Kentucky, which was formerly the Harrodsburg Springs Hotel in the late 1880s. *Author photo.*

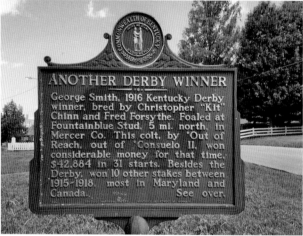

Bottom: Kentucky Historical Society sign reverse of "An Early Derby Winner" titled "Another Derby Winner," located at Youngs Park in Harrodsburg, Kentucky, which was formerly the Harrodsburg Springs Hotel in the late 1880s. *Author photo.*

a quarrel with Chinn. Chinn searched McCabe, and when he found no weapons on the man, he slapped him and turned him loose. He also saved the life of a Nicholasville train conductor Bob Meehan. Three hoodlums were terrorizing female passengers and shooting pistols. One of the men drew a pistol on the conductor. Chinn jumped in, took the guns away from the three men and threw the pistols out the window.[144]

His love of horses came from his father, who owned racing stables, and the firm of Chinn & Boyden built the "Old Fashioned Track" in New York City. Chinn owned a stock farm in Harrodsburg, Kentucky, and named the property after his most famous racehorse, Leonatus. He also grew tobacco and hemp. In 1883, a week before the Kentucky Derby, Leonatus won

the Blue Ribbon Stakes in Lexington. At the Kentucky Derby, the horse won the race by three lengths. Less than a week later, he won the Tobacco Stakes; three days later he won the Woodburn Stakes. He won again at the Hindoo Stakes, later known as the Latonia Stakes, where the horse was ridden by the famous African American jockey Isaac Murphy. The horse also won the Ripple Stakes, Himyar Stakes, Dearborn Stakes, Green Stakes and the Illinois Derby. The horse finished second in the Maiden Stakes. His overall record was ten victories in eleven starts, worth $21,435 ($628,854 today). Colonel Phil Chinn, Jack Chinn's son, wrote that Leonatus "was too handsome a horse ever to make a sire. I remember walking that horse all the way to Runnymede Stud in Bourbon County when we sold him to Col. E.F. Clay and Col. Catesby Woodford." In 1885, Chinn sold the horse Bankcroft to J.B. Haggin for $20,000 ($610,950) after the horse had won the Junior Champion stakes at Long Branch and sold his horse La Sak to William Whitney. He also raised Bax Fox, Lissack, Ingomar and Royal Arch. For many years, he was a starter on racetracks in Kentucky, New York and California, and part of the time he was assisted by his son Christopher "Kit" Chinn. The reason for his success as a starter at tracks throughout the country was his talent for getting jockeys to bring their horses up even for the break. He was a man of action. Phil Chinn stated that when his father had trouble with a jockey "who was trying to beat the start, he merely cautioned the boy with some off-hand remark such as "'Get your horse in line before I come down there and hit you with this plank.'" He was also a breeder and owner of racehorses.

During Governor William O. Bradley's administration, the Kentucky legislature was in a deadlock, when the Republicans, having control of the lower house, decided to unseat a Democrat in order to gain a majority on the joint ballot. The upper chamber was Democratic, and the presiding officer as well as the joint assemblyman was William Goebel. Goebel stated that if the Republicans planned to unseat a Democratic representative, he would depose two Republican senators. The Republicans disregarded his threat and decided to unseat the Democrat, so Goebel kept his word and appointed Chinn sergeant at arms of the joint assembly. Chinn said that he was in a race with deposed senator Walton to see who could reach the door first. The senator was trying to take his seat. Walton demanded from Chinn: "What was the meaning of this outrage? This blot on the law of our fair State? Stand aside and let me enter." Chinn said no to the senator and declared he could not, and the senator asked why. Chinn replied, "Because you part your hair in the middle." The senator asked why his friend—the other disposed

Governor William Goebel.
Library of Congress.

senator—was not to be allowed to enter. Chinn responded, "Because he don't part his hair in the middle." That night, Governor Bradley called out the militia of 1,800 men. Chinn returned to his home in Harrodsburg, and his entire force consisted of 700 men, but as soon as he heard of Bradley's action, he telegraphed him, demanding his unconditional surrender. When the matter reached the courts and the question was asked why calling out the militia was necessary, the governor's advisers replied that they had counseled the governor because of Chinn's quietude. The judge asked the governor's advisers what they meant by "Chinn's quietude." They answered, "I mean that when Jack Chinn is particularly quiet there is always the devil to pay."[145]

One of Chinn's best friends was Kentucky governor William Goebel. Chinn said that Goebel "was one of the greatest men this country has ever produced. He had the brain of Napoleon and he was no fair weathered friend, but he'd stick by you, right or wrong, whether you were in trouble or out of it." Chinn warned Goebel that a bunch of men had sworn to shoot him. Goebel told Chinn, "Let them shoot but let them understand that I've four grown sons and that with my dying breath I'll make them swear not to touch food or drink water until they've shot every scoundrel in this plot to kill me." In 1899, Goebel won the Democratic election for governor. His opponent was Republican William S. Taylor. Goebel won by two thousand votes. The Democratic majority contested the results, which led to tension and violence in Frankfort. Although Taylor was inaugurated in December 1899, the results of the election were still contested. On January 20, 1900, Goebel walked in front of the Old State Capital through the square where the capitol and executive building was located. Both Chinn and Goebel anticipated that they might be shot from the crowd. Chinn heard a bullet ring out, and Goebel fell to the ground. Chinn cried out, "They have killed you." When Goebel tried to get up, the bullets rattled around them. Chinn told Goebel to lie still while he stood over Goebel's body. Chinn's fingers were on the trigger of his pistol. Governor Taylor declared a state of emergency, called out the militia and ordered the legislature to adjourn. Secretly, the Democrats met in Frankfort and invalidated enough votes to declare Goebel the winner of the election.

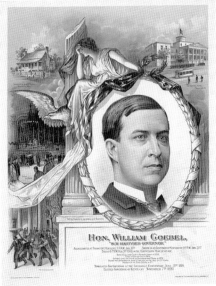

Top: Assassination of Governor Goebel. *From Harper's Weekly, 1900.*

Bottom: Governor William Goebel mourning poster. *Library of Congress.*

On January 31, 1900, Goebel was elected governor. His only act as governor was to counter Taylor's proclamation, order the militia to stand down and call for the legislature to reassemble. On February 3, 1900, Goebel died from his wounds. He served as governor for three days and was the only governor to have been assassinated while in office.[146]

Colonel Chinn was proficient in the art of head-butting as a weapon of defense and had an experience with a bully in Pittsburgh in which he used his head to knock out his adversary. During the 1896 Kentucky senatorial race, C.S. Blackburn, Democrat, ran against Dr. Godfrey Hunter, Republican, and the race was in a deadlock. Chinn was one of the prominent figures on the Democratic side and wanted to see Blackburn win the election. A prizefighter from Pittsburgh appeared in Frankfort and said he was looking for Chinn. Chinn was repeatedly warned of the threats being made by the prizefighter. The prizefighter found Chinn in a saloon, and the two men began a conversation. The prizefighter did not know he was speaking with Chinn. Chinn told the man that Chinn was a mild-mannered and inoffensive person who was not looking for any trouble with anybody, but the prizefighter became enraged, stated that he had been brought to the state capital to get Jack Chinn and proposed to do it as soon as he got the opportunity. Chinn gradually edged the bully against the wall and informed the prizefighter that he was Jack Chinn, the man he was looking for, and with his head he butted the bully on the point of his chin with a jolt that caused the bully to immediately collapse on the floor. Chinn

raised the man up and proceeded to head-butt him again. Afterward, Chinn went to the bar, made himself a drink and then kicked the prizefighter to the street. The prizefighter left Frankfort.[147]

During the Chicago presidential convention, the Democrats nominated Grover Cleveland, who would become president in 1884 and became a president for a second time in 1893. During the 1884 presidential convention, an old man engaged Chinn in a conversation. Chinn said, "I know Cleveland will win because Tammany Hall is against him." About a half-dozen Tammany Hall supporters, wearing tall, white hats yelled out that Chinn was a liar. About fifty men kicked Chinn up and down the convention center. Quickly, Chinn took out his knife and pointed the blade at several men; before a gun could be drawn, Chinn took the weapon out of the hands of his adversary.[148]

Chinn's reputation as a hair-trigger fighter spread throughout the United States. One time at the Southern Hotel in Chicago, Chinn registered at the hotel. Shortly after he had checked, in a man loaded with baggage entered the hotel and made arrangements to rent a room. He was signing the register but noticed that the name above his was "J.P. Chinn, Harrodsburg, Kentucky." The man dropped his pen, picked up his baggage with trembling hands and fled from the hotel.[149]

Chinn was known not only as a fighter but also as a man who cared about others. In the crowded streets of Louisville, a horse broke loose and was charging down the streets. An elderly, blind Black man was directly in line of danger with the horse heading straight for him. At a risk to his own life, Chinn threw his arms around the elderly man and carried him to safety. The Black man was trembling and thanked Chinn for rescuing him.[150]

Chinn was also a great foxhunter and took an active part in the National Fox Hunter's Association. He loved the hound as much as he did the chase. He bred and kept one of the best walker dogs and very rarely was a dog found in the pack that was not bred in his own kennels. He was a friend of the Walker Brothers of Garrard County and was a tireless hunter and fearless rider. At the 1909 meet at the National Fox Hunter's Association, he won First Derby with his dog Sal and Lady. He also won first in All Age Derby. Pete, winner of the National All Age, seemed to be his favorite dog.[151]

Chinn also had a connection with Frank James, the famous outlaw and brother of Jesse James. During the Civil War, the James brothers rode with guerrilla leader William Quantrill of Missouri. After the Civil War, Frank James visited Harrodsburg to look after the graves of four members of the

James gang who were buried in the Oakland Methodist Church Cemetery, about two miles west of Harrodsburg. Frank James wanted to pay his respects to his fallen comrades at the Oakland Cemetery. Frank James and some of his old comrades stayed at Chinn's home for several days as a guest. While staying at Chinn's home, Frank James made an impression on Chinn, and he found him to be quiet, pleasant and well-mannered. During the War, guerrilla leader William Quantrill, along with the James gang and their associates, were riding through Kentucky to reach Virginia. At least two of Quantrill's men stopped at Stanford, and one of the men began to drink. They began to talk, which led Union captain James Bridgewater and his scouts, who were recruited from the Stanford and Hall's Gap area, to discover the identity of the men. The scouts' official designation was Company A, Hall's Battalion, Kentucky State Guard. Bridgewater's men had been alerted at Stanford and followed Quantrill's men as they rode out of Stanford. Quantrill's men broke up into three squads and stopped at three houses along the road for dinner. The last squad was near the Oakland Church and was under the command of Sergeant John Barker. Bridgewater's men surrounded the house and took positions behind any cover they could find. Bridgewater's men opened fire into the windows and the doors. Sergeant Barker and his men were equipped with only revolvers, and the three were killed, including Barker. The survivors tried to make a run for safety, but they did not make their escape. The remainder of the men were either captured or wounded, including Jim Younger. Allen Parmer and Frank James rushed from the next house up the road but determined they could not escape. Quantrill's Second Lieutenant Chatham "Chad" Renick, who was in charge of the next squad, was killed. Parmer, James and the rest of the men made their way back to Quantrill and retreated to Nelson County.[152] People in the neighborhood buried the four men in the Oakland cemetery. The prisoners were taken to Lexington, Kentucky. Five of the guerrillas, including Jim Younger, escaped from the federal prison in Louisville and made their way back to Nelson County.[153]

On June 4, 1904, during Decoration Day, flowers were placed on the Confederate graves in Mercer County. Among the strains of patriotic music and wagons carrying loads of flowers, the graves of the soldiers in Spring Hill Cemetery, Harrodsburg, Kentucky, were decorated. Several speeches were made, including a speech given by Colonel R.C. Breckinridge from Danville, Kentucky. The memorable part of the ceremony was the reinternment of the remains of several Confederates who were buried in various parts of Mercer County during the Civil War. Among them

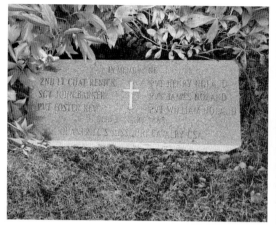

Left: Mass grave containing the graves of Second Lieutenant Chad Renick, Sergeant John Barker, Private Foster Key, Private Henry Noland and Private William Noland, who were members of guerrilla leader William Quantrill's Confederate cavalry who were killed in January 1865. The men were killed by Union cavalry and buried in the Oakland Cemetery in Harrodsburg, Kentucky, but later reinterred in Spring Hill Cemetery in Harrodsburg. Jesse James rode with Quantrill during the war. *Author photo.*

Right: Confederate cemetery, Spring Hill Cemetery, Harrodsburg, Kentucky. *Author photo.*

was Sergeant John Wright of the 41st Georgia Infantry, who was wounded at the Battle of Perryville and died of his wounds; and Lieutenant Chat Renick, Sergeant John Barker, Private Foster Key and Privates William, James and Henry Noland of Quantrill's command, who were buried in Oakland Cemetery, two miles west of Harrodsburg. Their remains were interred in the Confederate lot at Spring Hill. Frank James was invited to take part in the reinternment ceremony. He wrote a letter dated May 30, 1904. He wrote:

> *I just received a communication from Col. Jack Chinn informing me that my dead comrades, who met death bravely near Harrodsburg, while trying to make their way through Kentucky to join immortal Lee in Virginia, would be reinterred in the Confederate lot in your city on June 3, and requested that I be present on that occasion and make an address. There were four of our men killed at Mrs. Vanarsdall's, two of them mere boys and all as fine a set of fellows as ever followed the Bonnie Blue Flag. One of them, who was wounded, died while being taken to Harrodsburg a prisoner. I am not positive which one it was, but believe it was John Barker. The other three killed and who were laid to rest in Oakland churchyard were Lieutenant*

Commonwealth of Kentucky.

Office of SECRETARY OF STATE.

I, C. B. Hill, Secretary of State of the State of Kentucky, hereby certify that Articles of Incorporation have this day been filed in my office by the *The Chinn Mineral Company*

Said Articles of Incorporation show that the *The Chinn Mineral Company* has a capital stock of *Ten thousand dollars*, and the license fee of *Ten dollars*, which is one-tenth of one per cent. of the capital stock, having been this day paid into the Treasury as required by law, the said *Corporation is* now authorized under the laws of Kentucky to do business.

Given under my hand as Secretary of State, this *8th* day of *Sept*, 190*3*

C. B. Hill
Secretary of State.

By _____
Assistant Secretary of State.

Original Articles of Incorporation document for Jack Chinn's mine. *Courtesy of the Harrodsburg Historical Society, Harrodsburg, Kentucky.*

Chad Rennick and Henry and William Noland. I regret exceedingly that I cannot be present.…I cannot be present in person on June 3 nevertheless my heart and thoughts will revert to Harrodsburg on that day. I am respectfully yours. Frank James.[154]

In 1906 and 1908, Chinn served several terms as representative from Mercer County in the Lower House of the General Assembly and as a senator from Mercer County. He announced his candidacy for the Democratic nomination for congressman from the Eighth District and ran against Congressman Harvey Helm but withdrew from the race before the primary. He was the author of the law creating the Kentucky Racing Commission.

Chinn also owned a calcite mine in Mercer County. The mine was located on the Mercer side of the Kentucky River at the mouth of the Shawnee Run. The mine was near the village of Mundy's Landing in Woodford County and the town of Harrodsburg in Mercer County. The Chinn Mining Company also built a mill located at the mouth of the mine. The mill had the capacity of sixty tons of calcite per day. The product was shipped to High Bridge on

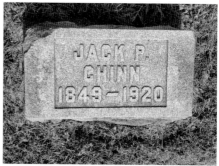

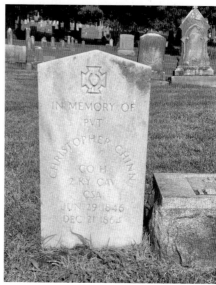

Top, left: *From left to right*: John Morgan Chinn and Ruth Gore Morgan Chinn; *top row*: Christopher Chinn and John "Jack" Pendleton Chinn; *bottom row*: Phillip Thompson Chinn and George Pendleton Chinn. *Courtesy of the Harrodsburg Historical Society, Harrodsburg, Kentucky.*

Top, right: Jack Chinn's grave marker, Spring Hill Cemetery, Harrodsburg, Kentucky. *Author photo.*

Bottom, right: Christopher Chinn, Jack Chinn's brother who was killed during the Civil War, Spring Hill Cemetery, Harrodsburg, Kentucky. *Author photo.*

Bottom, left: "Black Jack" Chinn's tombstone, Spring Hill Cemetery, Harrodsburg, Kentucky. *Author photo.*

a barge and loaded onto rail cars. The Chinn Mining Company came to an end after World War I.

After the Chinn mine was abandoned, it became home to Chinn's Cave House, a tourist attraction, restaurant and gas station on Highway 68. The attraction was run by Colonel George Chinn, a graduate of the Millersburg Military Institute and Centre College. Chinn was a colonel in the U.S. Marine Corps and co-inventor of the Mark 19 40mm automatic grenade launcher.[155]

To sum up Chinn's life in one story, an itinerant preacher paid a visit to Chinn's farm and found him sitting in his rocking chair on his porch with his hound dog at his feet and a shot of whiskey in his hand. The preacher heard that Chinn was not a churchgoing man and he asked that Chinn pray with the family. Chinn told the preacher: "Now brother, there's no one here except Mrs. Chinn, and she's the best woman that ever lived. In fact, she's a saint, and really doesn't need any praying for. She's taking a nap right now, and she's such a sure bet to get to Heaven that it really wouldn't be any use to disturb her."[156]

The preacher said: "Well, what about you sir? Don't you want to ask the Lord for something? His mercy is boundless and surely you need something from Him." Chinn replied, "Young man, do you see this house? Do you see this farm extending back to that ash tree? Five hundred acres as good as lies out of doors. There are eighty-five shorthorn steers in that field to the left and one hundred ewes in that field over there." With a sweep of his hand, he pointed out the areas to the preacher. He went on to say that "the barns are full of feed, and there's a crib of corn for those shoats behind the jack barn. All of it paid for. The Lord has been so much better to me than I deserve and has taken so much better care of me than I expected that I just wouldn't have the nerve to ask Him for anything else."[157]

On February 1, 1920, Jack Chinn died at the age of seventy-one at St. Joseph Hospital in Louisville, Kentucky. He had been in failing health for several years. His body was taken to Harrodsburg and buried in the family plot. He was survived by his wife, Ruth Morgan Chinn, and four sons: Morgan Chinn, who was chief deputy internal revenue collector, Louisville; Christopher Chinn, California; George Chinn, Harrodsburg; and Philip Chinn, Lexington.

ANDERSON WADDILL

KING OF ALL THE GAMBLERS

Anderson Waddill was born on October 22, 1833, in Tuscumbia, Alabama. His father, J.A. Waddill, was one of the wealthiest cotton planters in that part of Alabama. He married Mrs. Booth, a daughter of a planter, who was just as well known. Anderson was their only child. As a child, he was allowed to indulge in every pleasure. He had a private tutor, and Waddill grew up in luxury. As a young man, he longed for excitement and rode his father's finest horses around his plantation. At the age of twenty, he received the finest education that money could buy and gained a social position in the community. He attended the finest college in the South for four years, and the wild friends he met while in college gave him a taste for the reckless life. His father died and left him with a fortune. Waddill traveled to New Orleans and took with him a large amount of cash. He had a fondness for gambling and became a noted player.[158]

One night, he met J.J. "Old Man: Bryant, who was a widely known character of New Orleans and was famous as the most successful gambler of the South. Young Waddill watched Bryant play and admired him. Bryant noticed Waddill and picked up on the young man's ability as a faro player, and the two became very good friends. They started a faro gambling house in the heart of the sporting district in New Orleans and accumulated a large amount of money, but lady luck left them, and the house began to lose large sums. After six months, Waddill left Bryant and traveled to Nashville.[159] In 1867, Bryant was shot and killed in the St. Charles Hotel in New Orleans by Judge Frederick Tate, a well-known Texas lawyer.

When Waddill arrived in Nashville, he set up a mercantile business, but the lure of gambling found him playing nightly at one of the finest resorts. He won back what money he had lost in New Orleans. On October 7, 1876, Waddill was arrested on a westbound train by a police officer in Nashville and brought back to the city. A grand jury and a preliminary trial were held in Nashville, Tennessee, for the murder of Al Kirkland. Since so many people knew the popular Waddill for his charity for the local churches and that he was a power in politics in the Eleventh Ward, the venue for the trial had to be moved from Nashville to Ashland, Tennessee. A steamboat took the jury to Ashland for the trial.[160]

On February 23, 1877, the murder trial began. The state was represented by Attorney General A.J. Caldwell, William G. Brien, S.W. Childress and Clay Roberts. Waddill's lawyers were Confederate general William Bates, General George Maney, General W.A. Quarles and William A. Thomas. The judge was James Rice. According to eyewitness testimony, on October 6, 1876, Al Kirkland and Anderson Waddill walked into No. 59 Church Street, which was a gambling house in Nashville. The time was 11:45 p.m. There was no gambling going on, and after the men came in, the game of faro was played by a Mr. Singleton, Mr. Wand, Mr. Cook, Mr. Norman and Mr. Scruggs. Kirkland asked Waddill to loan him gambling chips amounting to twenty-five dollars, since he had lost all his money. Waddill said he did not know the man and asked Wand if he knew him. Waddill proceeded to give Kirkland the chips. Waddill said to the dealer, "Don't turn, I am going to quit and go home," but Kirkland refused to let Waddill have the chips back. Waddill reached to get the chips, and Kirkland knocked his hand up. At the same time, both men stood up, and Kirkland struck Waddill and knocked him up against the wall. According to eyewitness testimony, Waddill did not give Kirkland cause for offense. Kirkland was violent and abusive. Waddill did everything he could do to prevent hostility. The two men clutched each other, and H. Clay Price grabbed Waddill while Charlie Wood grabbed Kirkland. Kirkland tried to get back to Waddill, but Wand seized him and put him out the back door. The trouble occurred on the first floor. According to Price, Waddill was held down on the floor for a minute. He tried to get away from Price and kept saying, "Let me loose, you are holding me for another man to kill me," and pulled out a knife. Price shoved Waddill out the door and ran back to the front of the house, and when he looked, Kirkland was coming back into the door. Waddill got up and started in the direction of the back door. Price broke the two men apart twice. A man yelled out, "Clay," and saw both men fighting; Kirkland was on top of Waddill with

his left hand on his neck and the other hand down on the ground. Waddill was on both of his knees and Kirkland on top of him. Price separated them again, pushed Kirkland back toward an alley and told him to go away. He started back at Waddill again, and Price gave him another shove. Waddill got up and went into the house and asked for his bat. When the two men confronted each other again, Waddill cut Kirkland with his knife. Waddill was bloody from the struggle. After he was cut, Kirkland was sitting on the steps of the gambling house. He was cut from his cheek up to the nose, and another wound led down to his throat, where an artery had been cut. He would die of his wounds later that morning. Waddill claimed self-defense; the jury found him not guilty of murder, and he was acquitted. Waddill learned that Kirkland had lost his last dollar that evening, and his desperation motivated him to attack Waddill. Waddill heard of about Kirkland's widow and children. He gave her a deed to a farm near Nashville, which he bought with money he had won, worth about $5,000.[161]

In 1854, Waddill met Rebecca Lesch, who lived with her father on a plantation in Benton County, Tennessee. They were married that year and lived with her father until 1864. Waddill's mother passed away, and he decided to move to Louisville. Almost the entire estate of his father had passed to his mother, even though she had married a second time and had two daughters from the second marriage. According to reports, when young Waddill arrived in Louisville at the beginning of the Civil War, his father's estate was worth between $50,000 ($943,665) and $75,000 ($1,415,498).[162]

When he arrived in the city, he associated himself with Fred Sloan, John Blakely and John Riddleberger. The Galt House was located at Second and Main Streets, where the Second Street bridge is currently located, and the three men started a faro bank on the opposite side of the street. During the Civil War, Union generals and officers made Louisville their headquarters, and Waddill's faro bank was a favorite resort for the officers. Waddill's place also became the headquarters for all the sporting men who visited the city during the war and received patronage from bankers, businessmen and others who had a fondness for gambling.[163]

Major Jake Castle joined the partnership, and Waddill and Castle opened up a faro bank on No. 102 Fifth Street. "No. 102" was famous throughout the South. Both Waddill and Castle were known as fair dealers and square in all of their transactions. Waddill expanded his gambling houses to other parts of the city. He opened No. 69 Third Street, and the largest amount of money ever won or lost in Louisville changed hands at his gambling house's tables. Waddill was at the height of his success. One night, Haverly's

Minstrels were playing in the city, and when his minstrel show was over, Jack Haverly, with a group of friends, headed to No. 69. The gambling house was packed, and Haverly's group began to play. Jack Haverly walked over to where Waddill was sitting and watching the games. Haverly said, "Mr. Waddill, I'd like to play with you for a while tonight. Are my checks good?" Waddill responded, "Yes, sir. Have a seat here. Your checks are good for any amount. The game started, and Haverly gave a check for $1,000 ($20,021) in chips. Haverly won until midnight and had accumulated several thousand dollars in Waddill's chips, but Haverly could not stop while he was ahead and continued to play until he began to lose all his winnings. By daylight, Haverly owed Waddill $6,000 ($120,126).[164]

Even though Haverly owed a large amount of money to Waddill, he continued to play and played high stakes, betting sometimes $1,000 on the turn of a single card. Luck changed again, and toward the close of the day, Haverly had won back all of his money back. Early in the action, the crowds deserted the other games and watched Waddill and Haverly in their card playing duel. Both men took turns eating and sleeping for three days and nights, when Haverly finally threw up his hands and said he was finished. Waddill had $27,000 ($610,717) in checks to the good, and he cashed them.[165]

Waddill also owned the Crockford, which was located on Third and Market Streets. Later in life, Waddill rarely played any card games. He had no favorite game but was proficient in all games. In his youth, he played all games for large stakes. Late in his life, he devoted his time to bookmaking and pool selling. In 1887, he bought the valuable property 239–41 Third Street. He opened a large poolroom known as Newmarket. Thousands of dollars were won and lost every day.[166]

He also loved fast horses and owned several of them. The value of his estate was $173,000 ($5,695,755). The property listed in his name on the books of City Assessor Murphy was assessed at $132,000 ($4,345,894). His wealth consisted mostly of real estate. He owned a two-story stone-front home on 630 West Chestnut and several other residences near the city. His Third Street property was very valuable. His daughter married J.G. Lucas, a planter from Trinidad, Louisiana, and he had four grandchildren. His most intimate friends considered him a charitable man. One winter, when the city's poor were in need, he handed Lum Simon a check to buy one thousand bushels of coal and told Simon to send the coal to the poor. He was Catholic. Before his daughter was married, the church called on her to take a subscription for an organ. She went to her father and asked for him

to give $100. He looked at the list, attached his name to the subscribers and gave the whole amount for the organ.[167]

His favorite hangout was Lum Simon's livery stable. On every occasion, when he left the crowd, he insisted on someone accompanying him to the streetcar. He hired ex–police officer Wash Ferguson to watch the Newmarket, and for years Ferguson was Waddill's shadow. Waddill had two half sisters who lived in Holly Springs, Mississippi. On August 11, 1893, he died at his residence at 620 West Chestnut Street in Louisville. He was complaining of intense stomach pain, and Dr. David Yandell found a malignant tumor in Waddill's abdomen. An emergency surgery was scheduled. The physicians declared the operation a success and believed he would live. Unfortunately, he took a turn for the worst, and his doctors knew he would die. He was surrounded at his bedside by his wife; his daughter, Mrs. J.G. Lucas of Trinidad, Louisiana; her husband; and his four grandchildren. He died quietly and peacefully. After his death, undertaker Gran W. Smith took charge of his remains. The funeral took place at St. Brigid's Catholic Church on Baxter Avenue. His pallbearers were Dennis Long, Major Edward Hughes, Byron Batoon, Aaron Kohn, M. Flynn and B. Frese. On news of Waddill's death, the Turf Exchange was closed early. He was buried in St. Louis Cemetery in Louisville, Kentucky.[168]

John Riddleburger

The Largest Faro Bank in the Central United States

<p>ohn Riddleburger was born in 1826 in Tennessee and came from a prominent family. His brother Samuel Riddleburger ran a restaurant in Nashville. John Riddleburger was six feet tall and well built in proportion compared to his brother. He also was well educated. He moved to Louisville during the Civil War toward the close of 1862 or the beginning of 1863. He opened a faro bank on Main Street between First and Second Streets. Before he moved to Louisville, he was joined by Anderson Waddill. In 1875, Waddill and Riddleburger ran the biggest faro bank in the central part of the country. During the 1870s, Riddleburger was also an important figure in gambling in Saratoga. In 1884, Louisville put a ban on faro bank business, and both men were restricted in their operations. From 1887 and 1888, they ran a faro bank in the Louisville. Both men acquired a large sum of money. At one point, Riddleburger had at least $100,000 ($3,119,063) in gold. He was largest depositor at the Louisville banks, and before his death he told Reverend Dr. T.T. Eaton, pastor of the Walnut Street Baptist Church, that at one time he deposited with a Louisville businessman $80,000 ($2,495,250) in gold for safekeeping.[169]</p>

Waddell and Riddleburger ran a faro bank on Main Street but moved to Fourth Street, between Main and Market. Later, the business moved to Fifth Street near Market Street, and the gamblers knew the business as "No. 102," which was the street number according to the old system of numbering.

For a couple years, they ran the bank and became rich, and their business became a topic of discussion throughout the country. Everyone knew what "102" stood for. From 102, they moved above Third Street just below the Louisville Hotel. While they were at their new location, Louisville passed laws to suppress gambling, and Waddill and Riddleburger dissolved their partnership. Riddleburger's wife died at the same time, so he moved east and made the gambling circuit at the famous resorts. He returned to Louisville after he had lost some of his money. He lived on Fifth and Breckinridge Streets, which was the only real estate he owned.[170]

In 1890, John B. McFarran Sr. introduced Riddleburger to the Walnut Street Baptist Church. From that point on, he never gambled again. For several years, he collected bills for different houses until he became too old.

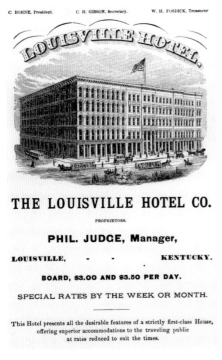

C. BOHNE, President. C. H. GIBSON, Secretary. W. H. FOSDICK, Treasurer

THE LOUISVILLE HOTEL CO.

PROPRIETORS.

PHIL. JUDGE, Manager,

LOUISVILLE, - - KENTUCKY.

BOARD, $3.00 AND $3.50 PER DAY.

SPECIAL RATES BY THE WEEK OR MONTH.

This Hotel presents all the desirable features of a strictly first-class House, offering superior accommodations to the traveling public at rates reduced to suit the times.

Advertisement of the Louisville Hotel. *From the* Kentucky State Gazetteer and Business Directory 1883–1884, *vol. 4, R.L. Polk and A.C. Danser, Detroit, Michigan, Louisville, Kentucky.*

For five years he lived over the Wide Awake restaurant on 335 Third Avenue. He received aid from the Walnut Street Baptist Church. In his later years, every Monday he would go to the bank, of which one of his benefactors was an officer, and withdrew five dollars as his week's allowance. At one time, he owned a plot at Cave Hill Cemetery, where his first wife was buried, but he sold his interest in the plot when he was in need of money. He was offered a nice salary to act as a clerk in a poolroom, but he refused the position, stating he no longer gambled. On November 22, 1905, Riddleburger died of Bright's disease at the City Hospital, where he had fallen and fractured his hip on November 3. His funeral was held at the Walnut Street Baptist Church, and he was buried in Cave Hill Cemetery.[171] Unfortunately, his grave has no marker.

JOHN WHALLEN

THE BUCKINGHAM BOSS

D uring the late 1800s, John Whallen and his brother, James Whallen, became the political bosses of Louisville and part of the political corruption in Louisville. From his "Green Room" in the Buckingham Palace, John determined the outcome of elections for mayors, controlled the Democratic committees in Louisville and even influenced the races for senator. After his death, his estate became Louisville's Chickasaw Park.

John Whallen was born in New Orleans in May 1850. His brother, James "Jim," was born on December 4, 1856, in Maysville. They were the sons of Patrick and Bridget Burke Whallen. When John was only a baby, his parents moved to Kentucky and settled in Maysville. When he was seven years old, his father died, and Whallen had to make his own way in the world. His mother moved to Newport. In 1861, when the Civil War broke out, Whallen decided to join the Confederacy. Despite being only eleven years old, he convinced Confederate recruiters to allow him to join the Confederate service. John Whallen became one of the youngest soldiers to join the Confederacy. Initially, he was a gunpowder carrier for John J. Schoolfield's Kentucky Battery and later a courier for the Confederate Fourth Kentucky Cavalry under Captain Bart Jenkins's battalion of General John Hunt Morgan's cavalry. During the war, he spent most of his time in southeastern Kentucky and along the Virginia border. General Basil Duke and Captain Bart Jenkins wrote that Whallen was one of their best soldiers.

After the war, at the age of fifteen, he returned to Kentucky and found a job in a store in Campbell County. He quit the store and moved to Newport,

JOHN H. WHALLEN.

John Whallen. *Ben Labree, editor,* Notable Men of Kentucky at the Beginning of the 20th Century (1901–1902), *George Fetter Printing Company, Louisville, Kentucky, 1902.*

Kentucky, where at the age of eighteen, he found a job as a policeman for the Newport Police Department. He quit that job and became a member of a construction crew that was building the Cincinnati Southern Railroad. In 1871, he came to Louisville and became a superintendent of a large quarry. With the money from being a superintendent, he bought a saloon on Green Street (Liberty), between Fourth and Fifth Streets. He wanted to draw people to his saloon, so he came up with the idea of a glass of beer for a nickel. The glass was so large that one had to use both hands to handle the glass. The "Big Beer" idea was a huge success. He moved to Third Street and opened the old Metropolitan Theater, which was a vaudeville theater. His theater burned down, so in 1878, he started a circus; however, the business failed. In 1880, his brother, James, who had been a policeman in Cincinnati, joined John in Louisville. Both John and Jim Whallen started the Buckingham Theater, which was a burlesque theater, located on West Jefferson Street. The theater catered to male patrons from all levels of society—but in particular the Irish and German immigrant laborers—and became one of the "finest variety theaters in the county."[172] In 1894, he opened the Grand Opera Theater at 211 West Jefferson Street. John expanded his business and owned two Brooklyn theaters, the Empire and the Casino, and produced a road show titled *The South Before the War*. The cast of the show became one of the most successful touring companies during that period. Whallen also wrote a burlesque show called *Brookenbridge*, which was a parody on the breach of promise trial of Confederate colonel W.C.P. Breckinridge, who was a well-known politician and journalist. In 1897, Whallen and other theater owners founded the Empire Circuit, the first burlesque syndicate, comprising thirty-seven theaters in which burlesque acts played in rotation for a full season's employment.[173]

With the success of his burlesque theaters, he wanted to protect his business interests. The burlesque shows had the vices of alcohol, gambling and prostitution, and several organizations tried to shut down his theaters. The police raided his theaters, so Whallen decided to become involved in politics. He became one of the most prominent Democratic leaders in Louisville

WHALLEN'S BUCKINGHAM
THEATRE.

Jefferson Street, Louisville, Ky.

J. P. WHALLEN, · · · · · Sole Lessee.
J. H. WHALLEN, · · · · · · Business Manager.
COL. SAVAGE, · · · · · · · Treasurer.

A NIGHT IN LOUISVILLE
IS INCOMPLETE WITHOUT YOU

PAY US A VISIT.

OPEN ALL THE YEAR ROUND.

The Representative Amusement Resort of the Southwest.

WAYFARER WOULD YOU "DO" LOUISVILLE, THEN

HIE AWAY TO THE BUCKINGHAM
And Enjoy Three Hours of Laughter,
AFTER WHICH

OUR INVITATION CONCERTS
BY A FULL STRING BAND

In the BRILLIANT CAFE attached to Theatre.

Anyone Having Curiosities for Sale for a Museum, apply at the Buckingham.

Advertisement for the Whallen's Buckingham Palace. *From the* Kentucky State Gazetteer and Business Directory 1883–1884, *vol. 4, R.L. Polk and A.C. Danser, Detroit, Michigan, Louisville, Kentucky.*

and a political boss. He was known as the "Buckingham Boss." Barney "Big Mac" McAtee was a member of the city council and helped secure a saloon license for the two brothers. When McAtee ran for re-election for councilman from the Ninth Ward, he was opposed by John Gillen, Mayor John Baxter and the whole city administration. During the campaign, McAtee fell ill and could not campaign for his candidacy. John and Jim never forgot what McAtee did for them, so they helped McAtee win the election.[174]

In 1885, when P. Booker Reed ran for mayor, Whallen ran Reed's mayoral campaign from his Green Room at the Buckingham Theater. When Reed won the election, he appointed John Whallen chief of police. Reed told the local newspaper, "He has earned the place and you may rely upon it that he will get it unless unforeseen circumstances necessitate a change."[175] Whallen held the office from 1884 to 1886. With Whallen controlling the police department, there were no more raids on his theaters. According the *Louisville Courier-Journal*, Whallen was "one of the best chiefs the city of Louisville ever had."[176]

In the 1899 political primary, Whallen and John Dunlap tried to run the Democratic race to make sure their candidates won the primary. Dunlap was the state central committeeman. A.J. Hess, chairman of the 49th District, refused to "wear the collar of the Buckingham Boss [John Whallen] and do the things which he regarded as dishonest and unfair."[177] Dunlap requested his immediate resignation. Hess could not fight against Whallen and turned in his written resignation. Thirty minutes later, John Cochran, a brother of Owen Cochran, secretary of the State Central Committee, was elected to replace Hess at a meeting held at Frank McGrath's saloon on Seventh and York. Frank

McGrath worked for Whallen. The city and county committees were equally divided as to where to have an honest primary or any kind of primary. The four committee members who wanted an honest primary were in favor of adopting the list of election officers submitted by fifty candidates who were opposed to Whallen and the unfair election. The other four members of the committee argued that all candidates who had put up their money and had entered the primary were entitled to some voice in the selection of election officers. Whallen had to make sure that the committee stand was five to three in favor of an unfair election. Whallen made sure that Hess was out and Cochran was elected. McGrath made sure that he secured proxies from the precinct committeemen in order to elect Cockran. Cockran did not even live in the 9th District.[178] Whallen also had John Keane, who was a member of the Democratic City and County Executive Committee from the 10th Ward, removed and Frank Dugan elected in his place. Keane was an outspoken critic of Whallen, and Dugan was Whallen's chief political agent in the western end of the city and an anti-administration man. With the changes, Whallen had entire control of the Democratic City and County Executive Committees.[179] When asked where the exact locations for the voting places would be announced, the reply from the committee, which was controlled by Whallen, stated the announcement would come in a day or so. The delay made sure that the Whallen crowd would know where the polls were located.

John and Jim Whallen also started their own whiskey and retail business. They advertised that their specialty was mail orders. Their business was located on 219–27 West Jefferson Street. They were rectifiers, which meant they blended different company's whiskeys to make their own whiskey, which Whallen bottled, labeled and sold under his own labels. Their main brand was Spring Bank Lithia High Ball Splits, Spring Bank High Ball Splits, Spring Bank Lithia Cherry Phosphate and Paramount Pure Old Rye. John sold his Lithia water as an elixir with healing properties. John even named his estate Spring Bank Park, which later became Chickasaw Park. In 1892, Captain Bauer of the Secret Service raided the Louisville Lithograph Company and seized the plates and bills being struck off as an advertisement by the Whallen brothers. About five hundred bills along with the plates were seized by the government officials. Colonel John Whallen was amused by the seizure. He told the local paper that the bills were advertisements for his whiskey, and one side had a picture and the other side had a picture of his brother. He sent a number of them to Washington as samples to find if there would be any objection to him using them. He already had six thousand bills sent throughout the country. The bills sent to Washington looked way too

much like real money, and the Internal Revenue Service sent Captain Bauer to seize the bills and confiscate the plates.[180]

In 1900, Senator S.B. Harrell of Lyon County was running for governor. He charged that John Whallen gave him $4,500 to remain out of the caucus and oppose Goebel's contest for governor. Harrell swore out a warrant against Whallen, charging him with attempting to bribe a member of the legislature. Harrell was charged with obtaining money by false pretenses from John Whallen. Whallen testified before a grand jury that he met Harrell several times during the campaign. Harrell told Whallen that he could do a lot for him. Harrell stated he could stop the contest between Goebel and Taylor. He claimed that Goebel managers offered him $1,000 and the position of superintendent of the Hopkinsville Insane Asylum. He asked how he could make a contract with him if he had a contract with Goebel. Whallen asked Harrell how much he wanted to stop the campaign. He wanted $10,000 but settled for $5,000—but only if he stopped the contest. Whallen told Harrell he would lose a whole lot of money if Goebel became governor.[181]

In 1903, John Whallen tried to control not only the Democratic Party in Louisville but also the Republican gubernatorial race in Louisville. He was promoting August Willson, who later became governor over Colonel Morris Belknap.

In 1909, John and Jim Whallen helped elect W.O. Head as mayor of Louisville. In 1910, in gratitude to the Whallens, Mayor Head presented John and Jim Whallen with two large silver loving cups at an event at Riverview Park. About fifty people attended the event. Speeches were given by Mayor Head and Major Colston. On each side of the cup was a life-sized rooster, the emblem of the Democracy, while the other had the words "Presented to Col. John H. Whallen by some of the boys in the trenches as a trophy of his splendid and successful services to the militant Democracy of Louisville and Jefferson County in the campaign and election of 1909." Louisville's most prominent businessmen and professional men donated the cups. Some of the donors were Judge Muri Weissinger, Judge S.J. Boldrick, Dr. John Buschemeyer, Colonel H. Watson Lindsey, Senator Mark Ryan, James B. Brown, Davis Brown, Major W.A. Colston, John D. Wakefield and Harry Robinson.[182]

Even though John Whallen was a political boss in Louisville, thousands of people adored him. In 1912, during a harsh winter in Louisville, John and his brother, Jim, established a relief station on Jefferson Street, near the Buckingham Theater. The relief station provided clothing, food, fuel, medicines and free provisions to those who were in need. People who had old clothing, extra bedding or other things that could be used by the poor

were donated to the Whallens, and John Whallen or one of his assistants would arrive in a wagon, load the donated items and transfer them to the relief station. Hundreds of women and men in Louisville received financial aid from the Whallens.[183]

In 1909, Orrie Whallen, John Whallen's only son, died at the age of thirty-six at Saints Mary and Elizabeth Hospital after suffering from pneumonia for four weeks. His father and his two sisters were at his bedside. He was born in Newport and educated in the parochial and high schools in Newport before moving to Louisville. He learned the plumber's trade under M.J. Duffy and was deputy clerk under Chief Alfred Oldham of the Police Court. He resigned to take charge of his father's Spring Bank Company and later became superintendent of the Spring Bank Lithia Water Company. He was buried in St. Louis Cemetery. He had no children.[184]

On December 3, 1913, John Whallen died, and his funeral was held at Holy Cross Church, on Thirty-Second and Broadway. His funeral was one of the largest ever held in Louisville up to that time. Almost every carriage in Louisville was engaged, and vehicles of every description were used, including cars. The General Council, the Board of Aldermen and the Board of Councilmen were at his home where his coffin was laid out. In his home, flowers reached the ceiling. John Whallen was a charter member of the Kentucky Colonels. He was also a lieutenant colonel on the staff of Major General William B. Haldeman, commanding the Kentucky Division of the United Confederate Veterans. Wagon after wagon pulled up to Whallen's home carrying flowers. He was also a member of the Hotel and Café Association of Kentucky.

The funeral cortege was a mile long and was the largest in the history of Louisville. Ninety-seven closed carriages and many cars carried the mourners. Twelve wagons carried the floral pieces from his home to the cemetery. In the carriages were his brother, Jim, and his wife; Ella Herfurth, daughter of John Whallen; Nora Moore, another daughter; and Thomas Whallen, a half brother. His active pallbearers were James B. Brown, Frank McGrath, Frank Dugan, former mayor W.O. Head, Mayor John Buschemeyer, J.H. Shea, E.T. Tierney and Charles Cronem. He had sixty honorary pallbearers, including Milton T. Smith (president of the Louisville and Nashville Railroad), General William Haldeman, General Basil Duke, Judge Shackelford Miller, Louis Seelbach, General John B. Castleman, Frank Fehr, R.W. Knott, Colonel Harry Weissinger, Judge Henry Barker and Samuel Casseday.[185]

His body was placed in the family mausoleum in Louisville's St. Louis Cemetery. Hundreds of floral tributes were placed around the mausoleum. His casket was placed next to his wife. When he died, he left his entire

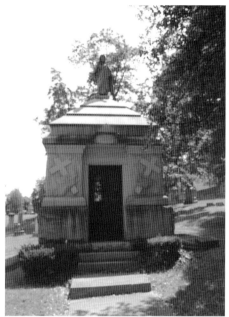

Left: Whallen mausoleum, St. Louis Cemetery, Louisville, Kentucky. *Author photo.*

Right: Stained-glass window in the Whallen mausoleum with the initials WB for Whallen brothers, St. Louis Cemetery, Louisville, Kentucky. *Author photo.*

estate to his brother, Jim. John Whallen was the showman and was always in the limelight while his brother remained in the background looking after details. Both John and Jim owned their possessions jointly. They did not have separate bank accounts. The money was deposited into a common fund. The bulk of the estate was split between his daughters and his half brother. All of the property was held jointly by the two brothers. He left the running of the Buckingham Theater and Empire Circuit Company to his brother, Jim.

In 1914, the Board of Park Commissioners accepted the offer from Jim Whallen to place a memorial in honor of his brother, John, in Shawnee Park. A rest house would be erected costing $10,000.[186]

In 1921, the Board of Park Commissioners bought fifty-three acres, including the home and farm of John H. Whallen on Greenwood Avenue, for $78,000. The spring on the property furnished the Spring Bank Water. His home became a shelter house. The new park became Chickasaw Park.[187] His Buckingham Theater later became the Savoy Theater. In 1947, his home at 4420 River Park Drive was demolished and became the site of Bishop Flaget High School.

Henry Wehmhoff

Owner of the Turf Exchange and the Suburban

Henry Wehmhoff was born on November 25, 1860, in Louisville, Kentucky. His father, Henry Wehmhoff, was born in Germany and was a tailor and upholsterer. Henry Wehmhoff, the son, was known to all the racehorse men in the country and proprietor of the Turf Exchange. For several years, he was in the real estate business after he retired from the Turf Exchange. He was a close friend of Edward Hughes. On July 27, 1885, he married Cordelia Stinson Wehmhoff.

In September 1894, a meeting of the stockholders was held, and the new Louisville Jockey Club was organized. The leadership included William Schulte (president), Emile Bourlier (vice president), Colonel Meriwether Lewis Clark (presiding judge), Charles Price (secretary), Henry Wehmhoff (treasurer) and directors W.E. Applegate, Henry Wehmhoff, Emile Bourlier, W.F Schulte and W.G. Osborne. Wehmhoff stated that the new Jockey Club should spend money to make the track attractive and insisted on conducting the business based on the strictest business lines. He was regarded as one of the most reliable businessmen in figuring the risk or outlay of a large amount of money. He was already worth $75,000 due to his large interest in the Turf Exchange. The new president and directors immediately went to work improving the stables and buildings at Churchill Downs. Some of the buildings were torn down, and the grandstand was remodeled with the stands being built on the opposite side of the track to avoid the glare of the afternoon sun. Bourlier spent between $20,000 and $50,000 to upgrade the track and buildings for the spring meet. Large

purses would be offered, and no effort was spared to bring in the best racehorses to compete.[188] Bourlier stated he wanted the derby to be run on a mile and a quarter or mile and a half.

In 1896, Wehmhoff, who owned the Suburban and the Turf Exchange, was charged with running a common nuisance. He was acquitted. In 1898, Cordelia Stinson Wehmhoff sued Henry Wehmhoff for divorce and wanted $50 per week maintenance and $50,000 in alimony. The Louisville Jockey Club was made a party defendant. Henry Wehmhoff owned $25,000 of capital stock. Judge Field stopped Henry from disposing of any property and restrained the Jockey Club from making any transfer of any stock from Henry. He was also restrained from interfering with his wife on her custody of their daughter Ethel, whom they adopted in 1898. Cordelia charged Henry with infidelity and cruelty. He also claimed that his wife was guilty of cruel and inhumane treatment. Henry was also alleged to be the owner of half interest in a saloon in Boston and one-third interest in the Turf Exchange and the Newmarket poolroom, along with personal property that amounted to $100,000.[189]

On November 26, 1898, judgment was entered in the law and equity division dismissing the plaintiff's petition in the divorce case of *Cordelia v. Henry Wehmhoff.* The judge declared that the marriage was null and void, stated that they were never husband and wife and dismissed the case. Cordelia asked in her petition that Lilly Littrel be named as co-respondent. Henry denied that he was cruel and insisted he was not adulterer. He counter-sued and asked the marriage to be voided. He stated Cordelia was not his wife, alleging that when the ceremony by which they were supposed to be united occurred, she already had a husband. Henry stated that Cordelia was married on May 10, 1880, to Charles Long, and she never divorced him. He was living at the time when Henry got married to Cordelia. Two years later, she divorced Long. Henry also claimed that on June 19, 1896, she married Edward M. Johnson of Jeffersonville, Indiana. Henry presented exhibits of the records from the clerks at Evansville and Jeffersonville, Indiana. When presented with the records, Cordelia admitted the truth. She claimed that she thought she was already divorced from Long. The case was dropped.[190]

In 1898, Wehmhoff resigned as treasurer of the Louisville Jockey Club. In November 1898, Henry Wehmhoff and John Fay opened the Louisville Grain and Stock Exchange on 216 West Main Street. They set up private telegraph wires and long-distance telephone connections in order to carry on general brokerage business to take advantage of their clients in bonds, stocks and cotton and grain. At the time, Wehmhoff was a stockholder in many of

the leading local corporations and a director in several corporations. The business was managed by Charles Jefferies, who had a long history in the brokerage business.[191] During that same month, Wehmhoff was indicted for setting up and aiding a game of craps, setting up a game of roulette, setting up and assisting the setting up of a game of stud poker, setting up and aiding setting up a faro bank. Judge Barker threw out the charges. Judge Barker stated that he was at fault. He stated that he was going to stop gambling if the court had the power and that he was not against any particular gambler but against gambling. However, the indictments were thrown out due to the fact that the grand jury was illegally formed and the names were drawn by the judge, not by the jury commissioners. Thirty names were drawn instead of twenty. The names were drawn by not just the judge but the deputy circuit clerk, and the names of the grand jurors were known before the grand jury formed. The county attorney was present and knew the names of those who were indicted and the matter of the indictments. The sheriff did not summon twelve grand jurors selected by him but summoned them under the direction of the court. The grand jury was drawn in August during vacation. The jurors were drawn from the 1897 list and not of the 1898 list. The jury commissioners had nothing to do with the selection of the grand jury.[192]

On February 18, 1899, Cordelia Stinson, Henry's wife, died intestate, and the Columbia Finance and Trust Company was appointed administrator. At the time of her death, she owned several pieces of expensive jewelry, including a diamond sunburst worth $800; a gold watch valued at $100; one chatelaine to hold the watch, which was worth $35; one pair of turquoise earrings, each surrounded by seven diamonds, worth $100; a large four-karat diamond solitaire ring worth $500; one ring with diamonds and sapphires, worth $200; a turquoise ring surrounded by twelve diamonds; a pearl ring, surrounded with ten diamonds; one sapphire ring surrounded by twenty-five diamonds; one emerald ring; one solitaire diamond ring, surrounded by twelve diamonds; one opal ring surrounded by sapphires and diamonds; one turquoise with diamonds; and one locket with six diamonds, for a total value of $2,585. She had furniture worth $1,500. The Trust Company sued Henry Wehmhoff, alleging that he illegally obtained the property, and the Trust Company wanted all the items back. Wehmhoff stated that he owned the property after he purchased the items.[193]

In June 1899, he married Lillian Littrol of Cincinnati. In September 1900, Henry Wehmhoff was arrested at 243 and 245 Third Street and charged with setting up and running a game of chance. Wehmhoff was sitting in a chair at the Turf Exchange, smoking, and completely unaware

of the upcoming arrests. After being arrested, he was taken to the police station, and Jacob Greenburg, a pawnbroker, arrived and paid Wehmhoff's $600 bond. The police found blackboards at the rear of the bar. He was released on bond. He was indicted for running a horse-betting poolroom. There were blackboards with names of horses and odds written on the board. According to the police, Wehmhoff and his associates were only agents for the bookmakers at the various racetracks. Every commission was telegraphed to the bookmaker at the track, his approval needed before the bet could be received. The agents received a commission for every bet registered through their efforts.[194]

In 1901, Wehmhoff was brought to trial for maintaining a common nuisance, which was a poolroom. The specific allegation was that Henry Wehmhoff unlawfully permitted gamblers to assemble in a house in Louisville and engage in betting, winning and losing money on horse races to the common nuisance of the citizens of Kentucky. In September 1901, the jury handed down a verdict. Henry Wehmhoff was found not guilty of maintaining a public nuisance by running a poolroom. Wehmoff denied he was the owner of the Turf Exchange but did admit he was manager. B.H. Alvey alleged he lost $2,760 when he bet on horse races at the Turf Exchange. The prosecuting attorney tried to connect Wehmoff with the Turf Exchange. Two deed books were presented as evidence showing that the Turf Exchange was a corporation and had transferred the property on Third Street to Wehmhoff on June 14, 1899, for $18,000, of which $8,000 was paid in cash and the remainder in notes of $5,000 each. The books also showed that Henry Wehmhoff transferred his property to his mother, Wilhelmina Wehmhoff, on March 8, 1900, for $1.[195]

The judge declared that the act of pool selling was not a felony and that the paraphernalia connected with the poolroom was not gambling equipment under the Kentucky statutes. The question that arose was what rights and duties did the police have on the premises of the gambling houses. Police had the right to detect gambling, bring the offenders to justice and seize paraphernalia used in gambling—but only as applied to gambling outlined by the statute and to the use of implements felonious under the statute and not to articles perhaps used in the commission of a misdemeanor or connected with what was ordinarily known as a poolroom. The proof in the case showed only a single wager on a horse race. A disorderly house or common nuisance charge applied only to a series of acts committed at different times. The case did not show the evidence of a disorderly house and did not show that Wehmhoff owned, controlled or operated the business. The court deemed

that the police did have the right to order raids on the poolrooms and search the premises, seize the paraphernalia and arrest the person in charge of operating a gambling house. The people of Kentucky were protected from unreasonable searches and seizures, and all warrants must have probable cause. The only time in which a raid could be conducted and property seized without a warrant was if the articles were forbidden by law. At the time, under Kentucky state law, there was no statutory law authorizing the seizure of implements or the arrest of the keepers of poolrooms. During the arrests, the owners were legal saloon keepers and were licensed in both the state and city. The keeping of a disorderly house was only a misdemeanor. Since the crime was a misdemeanor, the police did not have the right to search without a warrant or take anything from the premises. The law stated that any game of change was illegal, including euchre, throwing of dice or even raffling a quilt at the church fair. You also could not sell liquor to minors or to someone who was drunk or to assembled men and women for the purpose of drinking and tippling.[196]

By 1901, Wehmoff had a bookmaking business with his business partner Johnny Fay. Their business was called Wehmhoff & Fay. Both men were at the Saratoga racetrack and won a considerable amount of money. Wehmhoff stated that the Saratoga racetrack in season was one of the greatest sporting resorts in America. His business partner Johnny Fay was one of the best-posted bookmakers in the West. He was rumored to have won $60,000 at Saratoga. At the opening of the Sheepshead Bay Race Track meeting, which ran from 1888 to 1910 in Sheepshead, New York, when the futurity was run, Fay won a small fortune.[197] Henry Wehmhoff, who was also a bookmaker, was one of the largest winners outside of New York on the eastern tracks. He was $60,000 ahead and a steady winner all season. In that same year, on Derby Day, May 10, the horse Henry Watterson, a three-year-old chestnut, won the feature race at Churchill Downs, and Henry Wehmhoff won thousands of dollars. Henry Watterson's price opened at twenty to one odds, and Henry Wehmhoff, along with Johnnie Fey, who formerly owned the son of the horse The Commoner, went into the ring betting fives, tens and twenties on the colt to win. The steady play caused the odds to recede from thirty to one to eight to one to ten to one at post time.[198]

In 1902, the grand jury indicted James Pirtle and Wilhelmina Wehmhoff for allowing poolrooms on property they owned. Mrs. Wehmhoff, Henry Wehmhoff's mother, owned the Turf Exchange. The grand jury investigated the poolrooms and were not able to find the proprietors, so they returned indictments against the owners[199] Henry Wehmhoff was acquitted of the

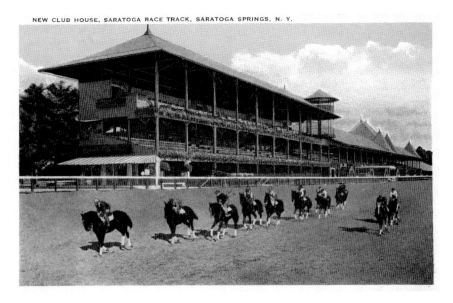

NEW CLUB HOUSE, SARATOGA RACE TRACK, SARATOGA SPRINGS, N. Y.

Postcard of the Saratoga Racetrack, Saratoga, New York, 1910. *Author's personal collection.*

charge. Witnesses claimed that they did not know if Wehmhoff was the owner of the exchange and never saw him in charge. The watchman at the exchange testified that his duties were to preserve order and keep minors from buying liquor.[200]

In 1903, Wilhelmina Wehmhoff transferred the Turf Exchange property to Henry and Moses Levy for $25,000. In 1904, the grand jury indicted Henry Wehmhoff, Edward Alvey and Charles Bollinger with operating a poolroom south of Louisville. They were charged with "unlawfully keeping and maintaining a public nuisance." The maximum fine was $5,000 and jail time. According to the indictment, Wehmhoff had a poolroom at in the intersection of Seventh and P Streets where betting on horse races occurred.[201] Colonel Sebastian Gunther, chief of police, started on a tour of the poolrooms and left an order stating, "You must close tonight." At the Turf Exchange, one of the most popular poolrooms, carpenters were dismantling and tearing out the blackboards, and other men were loading gambling paraphernalia on wagons to be moved to their new location outside the city. The same scene was taking place at the Kingston and the Mecca. The new building was located at Jockey Club Park. Wehmhoff stated that the Mecca would permanently close. According to the *Louisville Courier-Journal*, poolrooms "are now a thing of the past....Silence will reign

in the three poolrooms where for years the eager crowds have gathered."[202] The maximum fine for running a disorderly house was $5,000 for each day the house was in operation.

In 1906, Wehmhoff and Fay both won a considerable amount of money at the Saratoga racetrack. Rumors circulated that they won $160,000—Fay $100,000 and Wehmoff $60,000. With the money they won, they bought more than a dozen residences. Both Faye and Wehmhoff owned racehorses, but they sold their interests in their racehorses. Their firm sold the colt Ed Tierney to turfman Charley Van Meter, which ran second in the Kentucky Derby and won other large races. Fay sold the colt Henry Watterson. After winning at the races in Saratoga, both men planned to travel to New Orleans to make books throughout the winter at the southern tracks.[203]

During that same year in 1906, the police raided Wehmhoff's poolroom on Seventh and P Streets. People were crowding around the betting window to place their money on the fourth race at Latonia. As soon as the police were recognized, the operations came to a halt. The telegraph stopped ticking, and the odds that were written on the blackboard for the race were erased. The police arrested John Golden, the telegraph operator; George Goetle, the board marker; and Jake Fais, the money taker. County patrolman Hugo Schultz and his deputy Lee Barbour performed the raid. Schultz told the newspaper that he was "determined to break up the county poolrooms and shall continue to raid them until they are compelled to shut up shop and quit business."[204] As usual, the three men arrested paid their bond of $100 and were released.

In 1916, Charles Johnson sued Henry Wehmhoff to recover $1,500 and $1,975. According to Johnson, in 1915, Wehmhoff received $1,500 from Johnson to convert the money for joint uses. Wehmhoff refused to pay the money back. He also alleged that in 1916, Wehmhoff received $1,975 to convert to his joint uses and refused to pay. Johnson lost the money playing faro in "a certain gaming house and business conducted in Jeffersonville, Indiana and in 1916 the losses occurred over nineteen separate occasions with the smallest amount at twenty dollars and the largest at $550.[205]

On August 15, 1920, Wehmhoff died in Jewish Hospital following an operation. He was buried in Cave Hill Cemetery. He was survived by his wife, Lillian Wehmhoff; a son, Henry Wehmhoff Jr.; a daughter, Dorothy Wehmhoff; and two sisters, Mary Wehmhoff and Johanna Wehmhoff. Lillian was made an administrator of his will. His life insurance amounted to $25,000, which was paid out to his son. There were also $10,000 in liberty bonds. At the time of his death, the only property that Wehmhoff owned

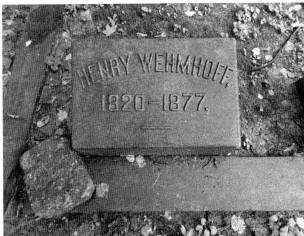

Top: Henry Wehmhoff's plot, Cave Hill Cemetery, Louisville, Kentucky. *Author photo.*

Bottom: Henry Wehmhoff grave marker, Cave Hill Cemetery, Louisville, Kentucky. *Author photo.*

was ten barrels of whiskey.[206] The ten barrels were worth $1,250 in medicinal purposes. Henry Wehmhoff had distributed his estate ten years before his death. He was worth a vast amount of money when he divided his estate. At the time of his death, his property was worth only $3,500, which was shared between his two nephews and two nieces. The Lincoln Savings and Trust Company was named administrator of the estate.[207]

JAMES RICHARDS WATTS

THE LAST OF THE GAMBLERS

James Richards Watts was born on September 18, 1835, in Louisville, Kentucky. His parents were Mitchell Vaughn Watts and Sally Morrison Lewellyn, originally from Lynchburg, Virginia. In 1833, they moved to Louisville. Mitchell sold horses under the business "Exchange Stables, M.V. Watts, Louisville." The business was located on the corner of Jefferson and Fourth Streets. Mitchel was an auctioneer of "valuable" horses, a dealer in fine carriages and of household goods. He also sold slaves and used enslaved laborers as household help. In 1847, Mitchell became master of the City Market House. The market master was in charge of collecting rent from the sellers and running a clear, orderly market. James and his brother John started their newspaper careers as printer's apprentices and eventually became prominent newspaper editors and owners. In 1848, the boys' mother died, and Mitchell remarried five years later. In 1856, he became a councilman under Mayor John Barbee. While serving as a councilman, he helped the mayor reorganize the Fire Companies. On July 2, 1856, at the age of fifty, Mitchell died, leaving his widow to care for a two-year-old daughter.

Young James Watts joined the volunteer fire brigade, and on January 5, 1855, he was elected assistant hose director for Kentucky Fire Company Number 5. Watts was only nineteen when he started a firehouse. He also completed his five-year printer's apprenticeship program. According to James Watts, he also ran a moonshine distillery in southern Kentucky in Lincoln County. His still made about four and a half gallons a day. Supposedly, a tornado took out his still and almost killed him, so he swore never to make moonshine again. He said that after the affair with making moonshine, he

moved to Louisville and returned to printing. In 1859, James was elected president of the Typographical Union. On November 6, he was charged with carrying a deadly weapon. In another court, he was indicted with "libel in publishing several of the printers of the *Louisville Courier*'s office as 'rats.'" They printed one thousand leaflets to distribute throughout the city. The dispute between the union and non-union newspaper printers turned violent over the insult of being called a rat, and a deadly shooting occurred.

James Watts married Elizabeth Frishe. Her father, Frederick Frishe, worked as a grocer, a real estate agent and an auctioneer. In 1855, Fred became a city magistrate. In 1860, James listed his occupation as a printer. He lived with his wife at her parents' home. In 1861, James ran for office and won. He also was appointed to a national executive committee with the Printers Union. He also ran for constable.

When Kentucky's neutrality was shattered in September 1861 and the Confederates invaded the state, James's younger brother Horace Mitchell Watts, who was twenty years old, joined the 4th Kentucky Mounted Infantry, Company K (Confederate). Horace enlisted as a corporal but eventually was promoted to second lieutenant. James took a different path and enlisted in Jefferson County in the 10th Kentucky Union Volunteer Infantry on September 6, 1861, and mustered in as a private at Lebanon, Kentucky, on October 1, 1861. The two brothers became sworn enemies. On November 13, 1861, James was promoted to second lieutenant of Company K, and on August 17, 1862, he was promoted to first lieutenant. From October 1862 to March 1863, Watts was acting regimental quartermaster. During September and October 1864, he was quartermaster and commissary. On November 21, 1861, the 10th Kentucky Infantry was organized at Lebanon, Kentucky, and mustered in for a three-year enlistment under the command of Colonel John Marshall Harlan. The regiment was attached to the 2nd Brigade, Army of the Ohio, to December 1861; 2nd Brigade, 1st Division, Army of the Ohio, to September 1862; 2nd Brigade, 1st Division, III Corps, Army of the Ohio, to November 1862; 2nd Brigade, 3rd Division, Center, XIV Corps, Army of the Cumberland, to January 1863; 2nd Brigade, 3rd Division, XIV Corps, to October 1863; and 3rd Brigade, 3rd Division, XIV Corps, to December 1864. Watts fought in the Battles of Mill Springs, Chickamauga, Lookout Mountain, Missionary Ridge, Peach Tree Creek, Vevay Creek, the Siege of Atlanta and Jonesboro. Watts was honorably discharged on December 6, 1864, when the 10th Kentucky Infantry mustered out of service on the same day.

When he was mustered out of the army in Louisville, he returned to the printer's trade and worked for the *Louisville Courier-Journal* as a typesetter but

began to take an interest in gambling houses. His first venture was above the Pearl Saloon at Fourth and Green (now Liberty) Streets. His second venture was over the Old Kentucky Club below where the Crockford stood. He moved across the street and started the Turf Exchange. He also owned an interest in a faro bank above the Crockford. He liked to play faro and keno and had a way to manipulate the games. He was witty, genial and a daring gambler. Soon he had the largest following of "sports" men in the city. He was an accomplished faro dealer. He made a great deal of money opening a keno bank. There was no limit when he held the box and made frantic plays. His gambling house was never questioned for its honest plays. He lost his money as easily as he won, scattering the money among his friends like a prince, and he never lacked players. Although he won a vast amount of money, he either squandered the money or gave it away. He gave money to charities, even if he spent his last cent.[208]

Watts made a rule that if a player at his games ever lost money to the point where his family suffered and the wife complained, he would return the money to the gambler without question. If a mother, father or wife asked for a sum of money, he paid, but the husband or father who lost the money in his gambling house would never be allowed to play there again. One of his admirers stated that when he was dealing faro, he would see men walk up to him and ask him for $100. Without even looking up from the table, he would hand a bill or two that amounted to $100. When the man left, James asked, "Who was that fellow?" James gave away thousands of dollars and never got back the money and never expected to get back the money.[209]

Another admirer related how quickly Watts lost his money. One time, Watts was going to leave Louisville on the midnight train for New Orleans but got distracted and walked into the Crockford. He played heavily, and when the time came and he had to board the train, he had lost $4,000. He put on his hat and did not even try to win back his losses.[210]

Watts also had many mistresses. In August 1882, on the third floor of Bradley & Mallory's printing company, on Third and Green (now Liberty) Streets, then

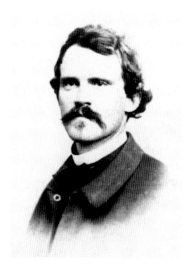

James Richard Watts. *Courtesy of Richard Watts.*

councilman Watts championed a woman before a crowd of frightened printers. The incident occurred when a printer stood on the back porch of the printing company and across the street a woman was sitting and dying her hair. The printer said something to the woman, and she told him off. Further words were exchanged between the printer and the woman, and the woman became angry. She ran into the house, and within a few minutes, Watts appeared on the scene. He marched upstairs to the printer's room and looked for the printer. The printers asked Watts who he was, and he replied, "Well, I'm Dick Watts, and I came here to shoot the son of a bitch who insulted that lady!" The guilty man in the room did not announce himself, and Watts did not shoot. The woman he had championed was the widow of a boxer named Carroll who had died years earlier in a bare-knuckle boxing match held behind the Crockford. The Widow Carroll proceeded to enter a house of prostitution on Preston Street and was a "kept" woman of Watts. He set her up in a luxurious apartment on Third Street, between Jefferson and Green (Liberty) Streets.[211]

Another story about another of Watts's mistresses occurred in 1884. Her name was Grace Arlington. On January 30, 1884, Watts and Arlington entered George Wolf's jewelry store, which was located on the corner of Fourth and Jefferson. Grace was one of the queens of demimonde, or a madam. Everyone knew that Watts was married and had children, but he made no secret of the fact that Grace was his mistress and he paraded her in the streets of the city. They were looking at diamonds, and Watts told the clerk that he wanted to give his girl a present. She took off her pair and placed them on the counter and put on the new earrings, which were valued at $450. They both walked out of the store. The diamonds were not paid for, but the bill was charged to Watts. George Wolf & Company sued Watts and Grace to recover the earrings. A reporter for the *Louisville Courier-Journal* paid Grace Arlington a visit at the house of Hattie Lawrence, which was located on Hancock Street, and asked her how she became the owner of the diamonds. She said that she had a very nice pair of earrings at the time and put them down on the counter and put on the new ones. She told the reporter that Watts owed her the money anyway and was merely paying her. She said that George Springer, a clerk at Wolf's store, demanded the earrings. She refused and consulted a lawyer, who told her she did not have to give them up. She told the reporter she had no intention of giving them up and said Wolf would have to get the money from Watts. She stated that she and Watts had been friends for a year, and when they ended their relationship, they parted "amicably."[212]

Grace was seen leaving the city and was about to board the Chesapeake and Ohio Railroad when she was confronted by Constable Sam Webb, who

had a bail sworn out by L.&E. Schulhafer, the Jefferson Street plumbers. She owed them seventy-five dollars for putting chandeliers in her house on West Madison Avenue. She was indignant when he saw the constable. When she learned that she could not leave the city until her bill was paid, she promptly paid the bill and left on the train.[213]

Watts was a close friend of Jim Crawford, who was a faro banker and ran a game in Cincinnati but was well known in Louisville. Watts was sitting at Crawford's game, and a great deal of money had changed hands. Watts was tired and said he would leave for Louisville on the next steamboat. Crawford told Watts to wait until the next day and he would travel with him. Watts decided to stay with his friend and returned to playing the game. He returned to Louisville broke after losing $15,000, which is equivalent to around $452,000 today.[214]

Watts was one of the first bookmakers in the West. In the 1870s, he opened a book-making shop in St. Louis. His shop was the only one on the track, and when the bettors found out that he would take bets on any horse, the "sports" men thought they could make a fortune. When the horse racing meet came to a close, Watts won $83,000, which is equivalent to $1,733,287 today. In 1879, he founded the Turf Exchange, which was located on Third Street, between Market and Main Street. The Turf Exchange was formerly known as the Walker's Exchange. He served food that was the "model of the culinary art," and the bar "was unequaled."[215] Watts intended to the make the Turf Exchange the headquarters for turfmen in the South and West. The business sold betting pools on legitimate turf events throughout the country. The Turf Exchange had the finest pool betting room. His partners were Ed Hughes and Bob Cathcart. The Turf Exchange made between $60,000 to $75,000 a year, which is equivalent to $1,777,866 to $2,222,331 today. Cathcart died, Hughes quit and Watts sold the business in order to open a magnificent gambling house in Louisville called the Palais Royal.[216]

He was a member of the General Council from the Fourth Ward in the city and served for three terms. Alderman Patterson, who served with Watts, told a story of when the General Council was going to expel Watts from the council because he ran a gambling house. He made a speech before the council stating that if he was expelled the council would be turning out the best-qualified member of the board. He said he made money enough where he was not liable to temptation of being bought by anyone and that he had no business that conflicted with his duties. He stated he was independent of the corporations and they could not influence him.[217]

Public sentiment turned against gambling houses, and the local newspaper declared war on gambling and wanted to know who owned the Crockford gambling house. Watts stood up during a council meeting and stated that he was the owner of the Crockford and intended to continue to run the business. At the same time, the cry rose out for more investigations from the city council to "shed more light on the gambling houses." Watts had the front of the Crockford fitted with electric lights, which illuminated Jefferson Street as bright as daylight. He said, "Now I suppose they have light enough on the Crockford." His defiant spirit led to the closing of his gambling house as well as other gambling houses in Louisville.[218]

The Law and Order Club formed, and the gambling houses were raided nightly. In the middle of winter, Watts continued to run his business. He spent endless nights watching guard over his games, even in the coldest weather. He contracted rheumatism. He also contemplated opening another business next door. He opened the Palais Royal. Watts advertised the opening of the business, and the anti-gambling crusaders pushed even harder against Watts until the gamblers were ousted and the houses closed.[219]

When he found out that gambling houses would no longer be allowed, he said he would obey the law. He started several small businesses, but they all failed. The Republican postmaster of Louisville offered him a little clerkship, which he accepted and became the weigher of mails. When the Democrats took over, he lost his job. In 1894, he announced he would run for the position of county jailer. An organization made up of a club of four thousand Democrats pledged to vote for him, and he was elected. He was not a good jailer. He was too indulgent with the prisoners and guards. The guards neglected their duties, and escapes occurred on his watch. He determined to do his best as an officer and offered rewards for the capture of the escapees, using his own money for the rewards. His record was so bad he was defeated in the next election.[220] The day after Christmas 1897, he slipped and fell while crossing Third and Jefferson Streets and sustained a severe bruise on his right knee. Two weeks later on January 17, 1898, he died comfortably at his home sitting in his chair. When news reached the papers, one reporter wrote an article on Watts and stated that he "was one of the best hearted men who ever walked the earth, a man who would not share, but who would give the last cent he had to one who needed it." Sam McKee, who knew Watts, wrote:

Watts was in the habit of carrying home his money in a market basket. One night he was held up as he was passing along a street. Watts got the drop before his highway men knew it, and then, walking them along in front

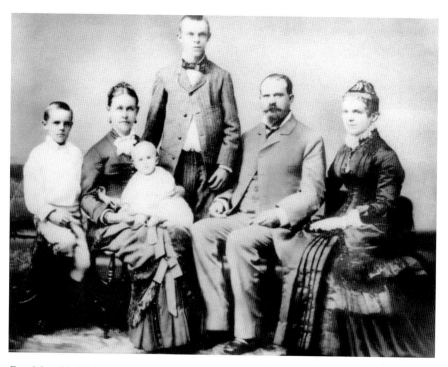

From left to right: Richard Watts, Henrietta Frishe Watts, Frank Watts and James Cornell Watts; *standing*: James Richard Watts and Elizabeth Watts, circa 1880. *Courtesy of Richard Watts.*

of him, Watts walked on home. Upon arriving home, Watts set down the basket, took out three bills without looking at the denominations, handed them to the thieves and ordered them to go about their business. That was the last time that he was ever held up.[221]

Phil Hacquettte, who knew Watts in St. Louis, wrote:

When he died there passed away a man of whom any one could be proud to say he was a friend. Watts used to come over to St. Louis and when he was here there was nothing too good for him. He always stopped by the old Planters' House. Every frequenter of the house knew him and liked the old man. He was a liberal spender, and I never saw him refuse to answer an appeal for help. This fact was so well known in later years that he was often imposed upon, but he would merely laugh when this was referred to any say he felt better for giving it.[222]

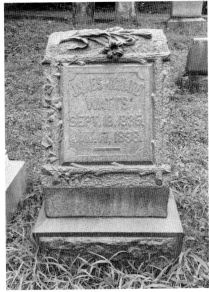

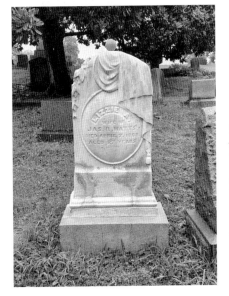

Above, left: Henrietta Watts, second wife of James Richards Watts, Cave Hill Cemetery, Louisville, Kentucky. *Author photo.*

Above, right: James Richard Watts's tombstone, Cave Hill Cemetery, Louisville, Kentucky. *Author photo.*

Left: Lizzie Watts, first wife of James Richard Watts, Cave Hill Cemetery, Louisville, Kentucky. *Author photo.*

More stories were told about his charity. On November 7, 1884, the tables at a church festival were almost vacant when Watts sat down at a table. Watts asked the lady who waited on him for a cup of coffee. After drinking the coffee, Watts handed the young lady a five-dollar bill and walked out, saying he did not need any change. The young lady turned to the cashier and asked if the bill was counterfeit. She asked who the man was whom she had waited on. The cashier told her that he was Dick Watts.[223] On December 24, 1894, Watts commented that the winter was the hardest he had ever seen on the poor. During his lifetime, in his house, he never had a lock on his coalhouse. His family told him that such as invitation would invite pilferers. He told his family, "Anyone who takes it must need it worse than we do."[224] His associates and co-workers at the

post office passed a resolution stating that "his cheerful voice and kindly advice are shut off from us forever, we feel we have lost a friend, and companion, and we commit his soul to a just and loving God."[225]

He was survived by his wife, Henrietta Watts, and four children: James, who lived in Yazoo City, Mississippi; Richard, who was with the Louisville and Nashville Railroad; Frank, who was with the Baltimore and Ohio Southwestern Railroad; and May Watts. On January 19, 1898, Watts's funeral was held at the Grace Episcopal Church. The pallbearers were selected from the force who served under Watts when he was jailer. The firehouse bells tolled during the procession of the funeral, and he was laid to rest at Cave Hill Cemetery.

NOTES

Introduction

1. Kleber, "Gambling," in *Encyclopedia of Louisville*, 329.

1. The Gambling History of Louisville

2. Ibid.
3. Green, *Gambling Exposed*, 103–4.
4. Kleber, "Gambling," 329.
5. Bush, *Louisville and the Civil War*, 13.
6. Ibid., 14.
7. Ibid., 15.
8. Ibid, 15–16.
9. Ibid., 30.
10. Ibid., 30.
11. Ibid., 39.
12. Ibid., 39.
13. Ibid., 40–41.
14. Ibid., 41.
15. Ibid., 49.
16. Ibid., 53.
17. Ibid., 104.
18. Walsh, "Louisville Was 'Wide Open.'"
19. Johnson, "Social Aid Economic History," 74.

20. Sfetcu, *Gambling Guide*, 399; Meg Groeling, "Games Soldiers Play: Chuck-a-luck," *Emerging Civil War*, https://emergingcivilwar.com/2017/08/15/games-soldiers-play-chuck-a-luck/.

21. *"Trumps,"* 202.

22. Ibid.

23. Ibid., 206.

24. Ibid., 206–8.

25. Ibid. 238–39.

26. Ibid., 453.

27. Ibid.

28. Ibid.

29. Ibid.

30. Ibid, 455.

31. Johnson, "Social Aid Economic History," 74.

32. *Industries of Louisville*, 14–16.

33. Bush, *Men Who Built Louisville*, 11–12.

34. Ibid., 32.

35. Walsh, "Louisville Was 'Wide Open.'"

36. "History of the Jockey Club," *Louisville Courier-Journal*, April 28, 1901.

37. Kleber, "Gambling," 329.

38. "A Rushing Business: Which Means That the Gambling Hells of Louisville Are in a Very Flourishing Condition," *Louisville Courier-Journal*, October 10, 1875.

39. Walsh, "Louisville Was 'Wide Open.'"

40. Ibid.

41. Ibid.

42. Ibid.

43. "New Albany, William Reynolds," *Louisville Courier-Journal*, December 20, 1883.

44. "Betting Rooms Consolidated: The Louisville Turf Exchange and Jockey Club Pool Rooms United," *Louisville Courier-Journal*, April 22, 1886.

45. Walsh, "Louisville Was 'Wide Open.'"

46. Ibid.

47. Ibid.

48. Ibid.

49. "Passing of Old Crockford Saloon on Jefferson," *Louisville Courier-Journal*, September 23, 1901.

50. "A New Newmarket," *Louisville Courier-Journal*, December 29, 1893.

51. "Passing of Old Crockford Saloon on Jefferson."

52. "New Newmarket."

53. "Latonia Is Sold to Judge Perkins: Applegate and Bollinger Dispose of Their Interests," *Louisville Courier-Journal*, May 17, 1900.

54. "Gambler's Paradise," *Daily Alta California*, January 29, 1885; "The Monaco of America: Louisville the Paradise of the Sports," *Daily American*, June 21, 1883; *Nashville Tennessean*, January 20, 1885.

55. "Gambler's Paradise."

56. Ibid.

57. Ibid.

58. "The Courts: Warring Against the Gamblers," *Louisville Courier-Journal*, October 3, 1876.

59. "The Law and the Gamblers," *Louisville Courier-Journal*, February 21, 1885.

60. "Got the Goose: The Law and Order Club Gets In Its Work on the Gamblers," *Louisville Courier-Journal*, July 1, 1885.

61. "Keno Banks Raided," *Louisville Courier-Journal*, August 20, 1885.

62. Stoddard, "Gambling," in *Stoddard's Encyclopedia Americana*, 180.

63. "Pool Rooms Must Go: The Law and Order Club Will Not Allow Gambling on Horse Races," *Louisville Courier-Journal*, March 30, 1886; "Arrest of Pool Sellers," *Louisville-Courier-Journal*, 1886.

64. "The Legal Record: The Respites of the Palais Royal Gamblers Filed, The Fees Paid, and the Prisoners Released," *Louisville Courier-Journal*, February 20, 1886.

65. "The Legal Record, A Jury Decides That the Turf Exchange Leases Have the Right To Sell Pools," *Louisville Courier-Journal*, May 26, 1886.

66. "Stopped the Deal: Every Gambling House in the City Closes Its Doors to the Players," *Louisville Courier-Journal*, September 11, 1892.

67. Kleber, "Gambling," 329.

68. Shafer, "Kentucky Lottery to Begin Selling."

69. Raymond, "How Decades Old Horse Races Saved."

70. Ibid.

2. Edward Hughes: Fire Chief, Gambler, Owner of the Turf Exchange

71. "Life Crushed Out of Maj. Ed Hughes: Struck by a Heavy Electric Car of the Pee Wee Valley Line," *Louisville Courier Journal*, July 20, 1903, 1.

72. Ibid.

73. Walsh, "Noted Characters Memorable to Louisville."

74. Ibid.

75. "Unavoidable: Was the Killing of Major Ed Hughes Coroner's Jury So Decides Motorman Made Sufficient Effort to Avoid Accident Evidence Not in Conflict," *Louisville Courier Journal*, July 23, 1903.

76. "Property Mainly Among Brother's Children, Maj. Hughes Will Filed, Leaves Largest Share to Frances Bernard Hughes," *Louisville Courier Journal*, July 23, 1903.

3. Steven Holcombe: Infamous Gambler Turned Missionary Preacher

77. Barry, "Romance of a Gambler."
78. Ibid.
79. Ibid.
80. Ibid.
81. Ibid.
82. Ibid.
83. Ibid.
84. Ibid.
85. Ibid.
86. Ibid.
87. Ibid.
88. Ibid.
89. Ibid.
90. Ibid.
91. Ibid.
92. "Aged Founder Dies at Mission," *Louisville Courier-Journal*, February 25, 1916.

5. Eli Marks: Gambler and Part Owner of the Crockford

93. Compiled Service Records of Confederate Soldiers Who Served in Organizations from the State of Kentucky, NARA, Letter from Major Thomas Webber, 2nd Kentucky Cavalry to General Samuel Cooper, Adt. & Inspector General, January 16, 1865.
94. Walsh, "Louisville Was 'Wide Open.'"
95. "Eli Marks: Death of a Widely Known and Remarkable Man, Truthful," *Louisville Courier-Journal*, February 20, 1895.
96. Ibid.
97. "Eli Marks: One of the Squarest Gamblers That Ever Turned a Card-Incidents Recalled By His Death," *Louisville Courier-Journal*, February 23, 1895, 16.
98. Ibid.
99. "Eli Marks: Death."
100. Ibid.
101. Ibid.
102. "Eli Marks Laid to Rest: Men From Many Walks of Life Come to Mourn," *Louisville Courier-Journal*, February 21, 1895.

6. Colonel John James Douglas: Prince of Sports

103. "Former Prince of Sports Dies, Col. 'Jim' Douglas Succumbs to Age and Disease," *Louisville Courier-Journal*, January 3, 1917.

104. "Douglas Horses Sold: Pilatus Brings $1,800, While Mayme Nutwood Sells for $340," *Louisville Courier-Journal*, October 4, 1905.

105. "Close Deal For Douglas Track: Money Paid and Property Transferred to Louis A. Cella," *Louisville Courier-Journal*, December 10, 1905.

106. "Big Turf Deal Goes Through: Owners of Churchill Downs and Douglas Park to Pool Interests," *Louisville Courier-Journal*, February 26, 1907, 8.

107. "For Creditors Committee Takes Over Affairs of Distilling Companies," *Louisville Courier-Journal*, September 17, 1915; "$70,000 For Creditors of J.J. Douglas Company," *Louisville Courier-Journal*, October 17, 1916.

108. "Douglas Will Contest Ends," *Louisville Courier-Journal*, August 29, 1917, 10.

109. Kleber, *Encyclopedia of Louisville*, 251.

7. Bob Cathcart: Pool Seller

110. "Bob Cathhart Dead: The Best Known Pool Seller on the American Turf," *Louisville Courier-Journal*, October 8, 1885.

111. Ibid.

112. Ibid.

113. Ibid.

8. James Cornell: First Person to Introduce Keno in Kentucky

114. "James Cornell: The Man Who First Introduced Keno in Louisville," *Louisville Courier-Journal*, June 9, 1884.

115. Ibid.

116. Display ad, "City Items: Cornell & Rogers," *Louisville Daily Courier*, December 25, 1867.

117. "James Cornell."

118. "The Rules Against the City Court Marshall," *Louisville Courier-Journal*, January 26, 1876.

9. Major David Ward Sanders: The Gamblers' Lawyer

119. Petrie, "Noted Characters"; Noel, "Life and Services," 331.

120. Petrie, "Noted Characters."

121. Ibid.

122. Ibid.

123. Ibid.

124. Ibid.

125. Ibid.

126. Ibid.
127. Ibid.
128. Ibid.
129. Ibid.

10. Emile Bourlier: President of the Louisville Jockey Club and Churchill Downs

130. "Sudden: Death Comes to Emile Bourlier," *Louisville Courier-Journal*, November 5, 1898.
131. "Pool-Rooms Must Go: The Law and Order Club Will Not Allow Gambling on Horse Races," *Louisville Courier-Journal*, March 20, 1886.
132. "The Turf Exchange Transfer," *Louisville Courier-Journal*, April 22, 1886.
133. "Derby Day: Brilliant Racing Expected at Churchill Downs," *Louisville Courier-Journal*, May 14, 1886.
134. Cain, "Legal Record."
135. "Jockey Club Organized," *Louisville Courier-Journal*, September 2, 1894.
136. "A New Deal: Jockey Club Assigns For the Purpose of Reorganization," *Louisville Courier-Journal*, August 7, 1894.
137. "A Gambling Case: Mrs. Rachel Smallwood Settles Her Case Against Bourlier Bros," *Louisville Courier-Journal*, March 4, 1896.
138. "Borne to the Grave: Thousands Attend the Funeral of Emile Bourlier," *Louisville Courier-Journal*, November 7, 1898.
139. "Jockey Club Sued By Mrs. Bourlier for Stock," *Louisville Courier-Journal*, January 11, 1901, 5.

11. Colonel John "Jack" Chinn: Gambler and Owner of the 1883 Derby Winner Leonatus

140. "Col. Jack Chinn, Noted Kentucky Character Dies," *Louisville Courier-Journal*, February 1, 1920; "Wilson Woodrow, Col. Jack Chinn: of Kaintucky Sah!," *New Metropolitan*, Volume 15, Issues 1–3 (1902): 247.
141. "Chinn and His Knife," *Fort Wayne (IN) News*, April 12, 1899.
142. "Col. Jack Chinn."
143. "Col. Jack Chinn"; "Wilson Woodrow, Col. Jack Chinn."
144. Ibid.
145. "Wilson Woodrow, Col. Jack Chinn."
146. "Col. Jack Chinn"; "Wilson Woodrow, Col. Jack Chinn."
147. "Do You Remember? How Col. Chinn Got Best of Pugilist," *Louisville Courier-Journal*, June 10, 1917.
148. "Col. Jack Chinn."

149. "Death of Noted Kentuckian, Colonel Jack Chinn of Munday's Landing Passes," *The Chase: A Full Cry of Hunting*, vols. 1–2 (July 1920): 13.

150. Ibid.

151. Ibid.

152. Yeatman, *Frank and Jesse James*, 66.

153. Ibid.

154. "Eulogies and Flowers for Dead Confederate Veterans," *Louisville Courier-Journal*, June 4, 1904.

155. "Chinn's Mine," *Abandoned*, https://abandonedonline.net/location/chinn-mine/.

156. McVey and Jewell, *Uncle Will of Wildwood*, 73–74.

157. Ibid.

12. Anderson Waddill: King of All the Gamblers

158. "A.M. Waddill: King Of All Gamblers Passes Away," *Louisville Courier-Journal*, August 12, 1893.

159. Ibid.

160. "Waddell's Trial: He Is Brought Before a Tennessee Court to Answer His Indictment for the Killing of Kirkland," *Louisville Courier-Journal*, February 23, 1877; "Waddell: He Is Granted a Change of Venue by the Criminal Court," *Daily American* (Nashville, TN), January 25, 1877.

161. "Waddell's Trial."

162. "A.M. Waddill."

163. Ibid.

164. Ibid.

165. Ibid.

166. Ibid.

167. Ibid.

168. Ibid.

13. John Riddleburger: The Largest Faro Bank in thr Central United States

169. "Famous Gambler John Riddleburger Dies a Regenerated Man," *Louisville-Courier Journal*, November 22, 1895.

170. Ibid.

171. Ibid.

14. John Whallen: The Buckingham Boss

172. "John Whallen to Leave," *Louisville Courier-Journal*, January 29, 1888.

173. Yater, *Two Hundred Years*, 147.

174. "Col. John Whallen Dies After Lying Unconscious for Two Days," *Louisville Courier-Journal*, December 4, 1913.

175. "The New Chief of Police: John Whallen to Head the New of the Police Department," *Louisville Courier-Journal*, December 29, 1884, 8.

176. "John Whallen to Leave," *Louisville Courier-Journal*, January 29, 1888.

177. "Scheme Laid Bare," *Louisville Courier-Journal*, June 9, 1899.

178. Ibid.

179. "Another Change Made in Democratic Committee," *Louisville Courier-Journal*, March 17, 1899.

180. "Raid on Whallen," *Louisville Courier-Journal*, March 25, 1892.

181. "Held: Harrell Must Answer to Grand Jury," *Louisville Courier-Journal*, January 28, 1900.

182. "Loving Cups," *Louisville Courier-Journal*, June 14, 1910.

183. "Relief Station for Poor Is Opened by Whallens," *Louisville Courier-Journal*, January 9, 1912.

184. "Young Life Ended: Orrie Whallen Dies After Illness of a Month," *Louisville Courier-Journal*, November 30, 1909.

185. "Final Tributes by Loyal Host," *Louisville Courier Journal*, December 7, 1913.

186. "The Whallen Memorial," *Louisville Courier-Journal*, February 5, 1914.

187. "Whallen Place Bought for Park," *Louisville Courier-Journal*, September 23, 1921.

15. Henry Wehmhoff: Owner of the Turf Exchange and the Suburban

188. "Jockey Club Reorganized," *Louisville Courier-Journal*, September 2, 1894.

189. "Demands a Fortune: Mrs. Henry Wehmhoff Asks $50,000 Alimony," *Louisville Courier-Journal*, November 3, 1898.

190. "Null and Void: Marriage of Cordelia and Henry Wehmhoff," *Louisville Courier-Journal*, November 26, 1898.

191. "Louisville Grain and Stock Exchange Formed by Well Known Louisville Men," *Louisville Courier-Journal*, November 12, 1898.

192. "Indictments Quashed: Gambling Cases Thrown Out by Judge Barker," *Louisville Courier-Journal*, November 6, 1898.

193. "Claims a Lot of Jewelry: Trust Company Brings Suit Against Henry Wehmhoff," *Louisville Courier-Journal*, March 24, 1899.

194. "Eight Men Charged with Operating Games of Chance," *Louisville Courier-Journal*, September 26, 1900.

195. "Not Guilty: Henry Wehmhoff Conducts 'No Pool Room,'" *Louisville Courier-Journal*, September 29, 1901.

196. "No Case," *Louisville Courier-Journal*, January 19, 1901.

197. "The Sport in the East: Henry Wehmhoff Talks of the Money at the Saratoga Track," *Louisville Courier-Journal*, September 2, 1901.

198. "Big Killing Made on Henry Watterson," *Louisville Courier-Journal*, May 10, 1906.

199. "Indictments," *Louisville Courier-Journal*, April 5, 1902.

200. "Acquitted: Alleged Poolroom Operators Go Free," *Louisville Courier-Journal*, February 8, 1902.

201. "Indict," *Louisville Courier-Journal*, March 31, 1904.

202. "All Over: With Three Poolrooms of Louisville," *Louisville Courier-Journal*, March 5, 1904.

203. "Messrs. Fey and Wehmhoff Return from East after Fine Season," *Louisville Courier-Journal*, November 13, 1906.

204. "Raid Wehmhoff's Pool Room," *Louisville Courier-Journal*, June 3, 1906.

205. "Suit Charges Two with Converting Money," *Louisville Courier-Journal*, August 15, 1916.

206. "$25,000 Is Willed to the Wehmhoff Boy," *Louisville Courier-Journal*, September 21, 1920.

207. "Barrels of Whiskey Constitute Estate: Henry Wehmhoff Divided Property Ten Years Ago Wife Says," *Louisville Courier-Journal*, September 2, 1920.

16. James Richards Watts: The Last of the Gamblers

208. "Old 'Dick' Watts: Last of the 'Sports' Who Made the City of Louisville Famous," *Saint Paul Globe*, January 31, 1898.

209. Ibid.

210. Ibid.

211. "Defending His Mistress," *Louisville Courier-Journal*, August 29, 1882.

212. "Diamond Dick: Councilman Watts Sued for Earrings He Presented to Grace Arlington," *Louisville-Journal*, March 25, 1886.

213. "She Paid the Bill," *Louisville Courier-Journal*, 1886.

214. "Defending His Mistress," *Louisville Courier-Journal*, August 29, 1882.

215. "The New Turf Exchange," *Louisville Courier-Journal*, February 5, 1879.

216. "Defending His Mistress," *Louisville Courier-Journal*, August 29, 1882.

217. Ibid.

218. Ibid.

219. Ibid.

220. Ibid.

221. "Last of the Old Gamblers: How Dick Watts Held Up the Highwaymen," *Louisville Courier Journal*, January 23, 1898.

222. Ibid.

223. "A Gill to the Orphans," *Louisville Courier-Journal*, November 7, 1884.

224. "Matters of Common Talk," *Louisville Courier-Journal*, December 24, 1894.

225. "In Cave Hill: Remains of Dick Watts Laid to Rest," *Louisville-Courier Journal*, January 20, 1898.

BIBLIOGRAPHY

Books

Alexander, Gross. *Steven Holcombe, the Converted Gambler: His Life and Work.* Louisville, KY: Press of the Louisville Courier-Journal, Job Printing Company, Louisville, 1891.

Bohn, Henry. *Bohn's Hand-Book of Games: Comprising of Whist by Deschapelles, Matthews, Hoyle, Carleton.* Philadelphia: Henry Anners, 1850.

Bush, Bryan. *Louisville and the Civil War: A History & Guide.* Charleston, SC: The History Press, 2008.

———. *The Men Who Built Louisville: The City of Progress in the Gilded Age.* Charleston, SC: The History Press, 2019.

Green, Jonathan. *The Gambler's Life, or, The Life, Adventures, and Personal Experience.* Philadelphia: T.B. Peterson, 1857.

———. *Gamblers Unmasked or The Personal Experience of J.H. Green.* Philadelphia: G.B. Zieber & Co., Ledger Buildings, 1847.

———. *Gambling Exposed: A Full Exposition of all the Various Arts, Mysteries, and Miseries of Gambling.* Philadelphia: T.B. Peterson, 1857.

The Industries of Louisville, Kentucky and of New Albany, Indiana. Louisville, KY: J.M. Elstner & Co., Publishers, 1886.

Kleber, John, ed. *The Encyclopedia of Louisville.* Lexington: University Press of Kentucky, 2001.

McVey, Frances Jewell, and Robert Berry Jewell. *Uncle Will of Wildwood: Nineteenth Century Life in the Bluegrass.* Lexington: University Press of Kentucky, 2005.

Sfetcu, Nicolae. *A Gambling Guide: Chuck-a-Luck*. N.p.: Multimedia Publishing House, 2014.

Stoddard, J.M. *Stoddard's Encyclopedia Americana: A Dictionary of Arts, Sciences, and General Literature, and Companion to the Encyclopedia Britannica (9th Edition) and to All Other Encyclopedias*. Vol. 3. New York, Philadelphia, London, 1886.

Tanner, Henry. *The Louisville Directory Business Advertiser for 1859–1860*. Louisville, KY: General Western and Southern Directory Publisher and Complier, 1859.

"Trumps," The American Hoyle, Or, Gentleman's Hand-Book of Games: Containing All the Games Played in the United States, with Descriptions, and Technicalities, Adapted to the American Methods of Playing. New York: Dick & Fitzgerald Publishers, 1864.

Yater, George. *Two Hundred Years at the Falls of the Ohio*. Louisville, KY: Heritage Corporation, 1979.

Yeatman, Ted. *Frank and Jesse James: The Story Behind the Legend*. Nashville, TN: Cumberland Publishing House, 2000.

Dissertations

Johnson, Edward, Jr. "A Social Aid Economic History of Louisville, 1850–1865." Master's thesis. University of Kentucky at Louisville, 1938.

Articles

Barry, Barry. "Romance of a Gambler Turned Preacher." *Louisville Courier-Journal*, October 10, 1915.

Cain, Paul. "The Legal Record: A Jury Decides That The Turf Exchange Lessees Have The Right To Sell Pools." *Louisville Courier-Journal*, May 26, 1886.

Noel, E.F. "Life and Services of David Ward Sanders." *Publications of the Mississippi Historical Society* 11 (1910).

Petrie, John. "Noted Characters Memorable to Louisville." *Louisville Courier-Journal*, August 20, 1916.

Raymond, Adam. "How Decades Old Horse Races Saved a Signature Kentucky Industry." *Spectrum News*, April 23, 2021.

Shafer, Sheldon. "Kentucky Lottery to Begin Selling Keno Tickets Monday Morning." *Louisville Courier-Journal*, October 31, 2013.

Walsh, Dan, Jr. "Louisville Was 'Wide Open' in Those Days." *Louisville Courier-Journal*, February 8, 1920.

———. "Noted Characters Memorable to Louisville." *Louisville Journal*, June 4, 1916.

Historical Societies

Compiled Service Records of Confederate Soldiers Who Served in Organizations
 from the State of Kentucky, NARA.
Publications of the Mississippi Historical Society

Index

About the Author

Bryan Bush was born in 1966 in Louisville, Kentucky, and has been a native of that city ever since. He graduated with honors from Murray State University with a degree in history and psychology and received his master's degree from the University of Louisville in 2005. Bryan has always had a passion for history, especially the Civil War. He has been a member of many different Civil War historical preservation societies and roundtables. He has consulted for movie companies and other authors; coordinated with other museums on displays of various museum articles and artifacts; has written for magazines, such as *Kentucky Civil War Magazine*, *North/South Trader*, the *Kentucky Civil War Bugle*, the *Kentucky Explorer* and *Back Home in Kentucky*; and worked for many different historical sites. In 1999, Bryan published his first work: *The Civil War Battles of the Western Theater*. Since then, Bush has published over fourteen books on the Civil War and Louisville history, including several titles for The History Press, including *Louisville During the Civil War: A History and Guide*, *Louisville's Southern Exposition: Favorite Sons of Civil War Kentucky* and *The Men Who Built The City of Progress: Louisville During The Gilded Age*. His newest books in 2021 were *A History Lover's Guide to Louisville* and *Bluegrass Bourbon Barons*. Bryan Bush has been a Civil War reenactor for twenty years, portraying an artillerist. For five years, Bryan was on the Board of Directors and curator for the Old Bardstown Civil War Museum and Village: The Battles of the Western Theater Museum in Bardstown, Kentucky and was a board member for the Louisville Historical League and is the official Civil War tour guide for Cave Hill Cemetery. In December 2019, Bryan Bush became the park manager for the Perryville State Historic Site.

Visit us at
www.historypress.com